PENRYN

THROUGH TIME

Ernie Warmington

AMBERLEY PUBLISHING

Acknowledgements

This is my fourth book on Penryn with more to follow. Penryn is the town where I was born in Bennett's Yard, and shortly afterwards moving to 83 'The Terrace', next door to Mrs Lorrimore's shop with my parents and only brother Reggie. I was schooled at the primary school almost next door, and then went on to technical college at Falmouth and Camborne. I served my apprenticeship with Silley Cox & Company, and then went to sea as an engineer with the British Tanker Company and the New Zealand Shipping Company, the latter as a senior engineer. I came ashore an married a Camborne girl and then went to live in Redruth, so really I have only lived in Penryn for twenty-one years. It is almost impossible to know it all about my home town; however, there is always someone you can turn to for more information. It is these people listed below I acknowledge for the help and understanding to compose this book, especially my wife Rosemary, for her typing and putting up with a disrupted household, to the publishers for allowing me to do as I wanted to, and once again this is dedicated to my parents and brother Reggie. For any names I have spelt incorrectly or anyone that I have missed out, any places or dates that I have got wrong I apologise.

G. James, M. Edwards, S. Richards, J. Penaluna, R. Hold, M. Bastion, J. Pellow, S. Booth, N. Young, M. Chamberlain, T. Dungate, Mr and Mrs A.T. Toy, Mr and Mrs J. Miller, M. Richards, M. Rich, V. Tullin, J. Basher, Rev. G. Warmington, C. Lang, M. May and L. Smuda (both former Mayors), K. Paul (Town Clerk), Mrs R. Hodges, A. Gosling, D. Owen, K. Kneebone, R. Pascoe, K. Loft, R. Holt, Mrs W. Toy, P. Smith, S. Head, P. Walker, M. Williams, N. Christophers, Canon J. Harris, Mr and Mrs C. Newby.

First published 2010

Amberley Publishing
Cirencester Road, Chalford,
Stroud, Gloucestershire, GL6 8PE

www.amberley-books.com

Copyright © Ernie Warmington, 2010

The right of Ernie Warmington to be identified as the Author of this work has been asserted in accordance with the Copyrights, Designs and Patents Act 1988.

ISBN 978 1 84868 543 7

British Library Cataloguing in Publication Data.

A catalogue record for this book is available from the British Library.

Typeset in 9.5pt on 12pt Celeste.
Typesetting by Amberley Publishing.
Printed in the UK.

Introduction

The port of Penryn, an attractive town with a lot of history, lies at the head of the river that flows into Falmouth Harbour. It covers 900 acres, now with a population of approximately 6,000, was mentioned in the Domesday Book of 1086, and an Italian Bishop founded the town in 1216. As the result of a dream a collegiate church was built at Glasney by Walter Brimscombe in 1265, taking two years to build from local stone as well as from Caen in Normandy (a model of which can be seen in the town's museum). Destroyed during the Reformation of Henry VIII and completely dismantled by Edward VII, much of the stone was used for building in the town. The first market charter was granted by James I to Penryn in 1621, then a lawless town with regular riots, smuggling, pick-pocketing and prostitution, fuelled by the many taverns, inns and breweries. With the development of the tin and copper trade in the Redruth/Camborne area in the seventeenth century, it brought prosperity to the town, handling large amounts of the ore as well as timber, gunpowder, fruit, meat, wool and Peruvian guano.

Sir Peter Killigrew, a businessman, saw the potential and had the customs due to Penryn transferred to a newly developing hamlet of Penny-come-quick. King Charles I was petitioned by both Penryn and Truro. He allowed the new upstart Falmouth to continue, granting them a charter in 1661. This makes Penryn more than 400 years older than Falmouth. In the early 1800s, a Scotsman named Freeman bought land alongside the river and developed a granite industry, taking granite from outlying villages. From these works were shipped huge quantities of shaped stone to London for buildings and monuments, as well as exporting all over the world for dry dock building, monuments and other important works. The era of the concrete saw the decline of the granite trade and Freeman's closed its gates in 1965. There are still some small granite quarries working for the building trade.

I find people fascinated by change; unlike my three previous Penryn books, this one is totally different. We all like to see the difference between then and now and are intrigued by changes to the local environment and the effect of having development with the loss of open spaces.

'Street furniture' is totally different from that of years ago. It now has yellow lines and designated spaces for buses to stop. In earlier times the roads were rolled stone and mud, with the total absence of the motor car. One hundred years ago, our forefathers would have walked or cycled to their place of work, with little or no evidence of tarmac, no street lighting, no sewage, etc. In earlier times shops stayed open sometimes until midnight, especially at festive seasons, all at bargain prices, as there weren't any refrigerators to rely on. Sunday trading was completely out of the question. Between 1900 and 1920 a few cars and motorcycles took over from ponies and horses, leisure time would mean dressing up in their best clothes to attend their place of worship on a Sunday and walking with their children perhaps to The Glebe, College Woods or down to the Quays to name a few. Churches too have changed. Buildings no longer needed for worship have been altered into living accommodation. The primitive Methodist Chapel at the bottom of St Thomas Street and the West Street Bible Christian Chapel are now flats. Clothes have also changed; gone are the long flowing dresses, bonnets and aprons, children going to school no longer wear short trousers, caps and pretty dresses and hob-nailed boots.

Crowds no longer assemble at the Town Hall to hear an election result. I well remember my father sending either my brother or myself down to Dicky Paul's on a Saturday evening, sometimes in the pouring rain, to get a copy of the *Evening Herald* just to get the football and rugby results. Will we ever see again the celebrations Penryn saw with Queen Victoria's Diamond Jubilee of 1897, the coronation of Edward VII, the Royal Cornwall show at Roskrow in 1873 and Carclew in 1932?

Street advertisements can be seen today in abundance which would have offended the religious and moral sensibilities of Penryn people a century ago. The graffiti and vandalism which mars so much of our current environment would be incomprehensible to Penryn's Edwardian residents. This is the first time I have had to introduce my own colour photographs; I have found it exciting but beset with problems. It's impossible to stop traffic and pedestrians at the same time to take a photograph in the same place as the older ones. In conclusion, you the reader are invited to study the contents of the following pages and see for yourself how the borough of Penryn has changed. In your opinion, has it changed for the better or worse?

Ernie Warmington

Falmouth Road, Penryn.

Penryn-Falmouth Road

This postcard, dated August 1931, is, as it states, on the Penryn-Falmouth road, taken, I think, from where the Penryn bypass ends on the roundabout just about where Freeman's Granite works starts and finishes. To the right would be Ponsharden shipyard and dry dock which is on the Penryn Boundary. Just over the wall was a landfill site made up mostly from Penryn rubbish for many years. This new photograph shows the road after it was widened, approaching the bridge to the left, with a motor garage and offices and industrial premises replacing the old granite works.

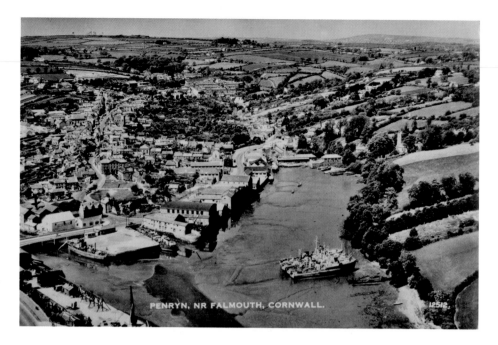

PENRYN, NR FALMOUTH, CORNWALL. 12512.

Penryn Port

An aerial shot postcard of the not too busy port of Penryn. In the bottom left hand corner can be seen what is left of Freeman's Granite Yard, Cox's premises, Anchor Hotel, Exchequer Quay, Annear's Coal Yard and all the businesses along Commercial Road. To the right is St Gluvias Church and cemetery, together with what I believe to be motor torpedo boats moored, when this scene was taken in around 1950. The modern equivalent photograph is not taken from the air but from a fire escape attached to an industrial unit looking towards the port of Penryn. Some buildings remain along the rear of Commercial Road whereas Freeman's have gone and cars are parked where the works used to be.

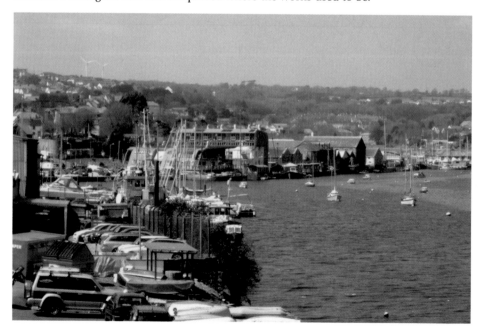

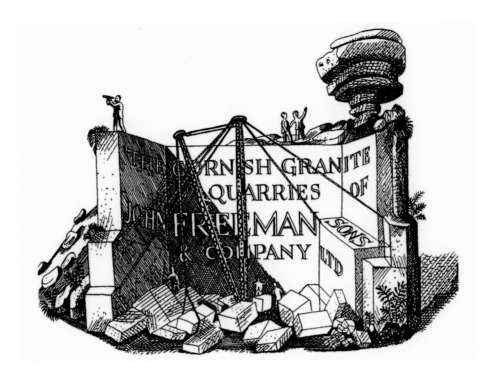

Freeman's Yard

It is as it states 'the Cornish Granite Quarries of John Freeman Sons & Company Limited' used in a book they published in 1933 explaining what granite is, its strength, and how it was used in engineering and architectural building. It also showed where some of their quarries were from the Cornwall/Devon border to Land's End. With the overhead steam crane working, this postcard shows where Freeman's yard was alongside the Penryn river. The cranes seen each end of the yard were used to load the granite block onto the little ships. On the opposite side of the river can be seen the cemetery of St Gluvias Church and what I believe to be Thomas's ship building premises, and to the left is seen Exchequer Quay and warehouses. It was impossible to retake this as a modern photograph.

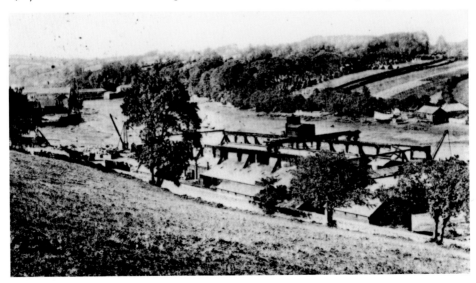

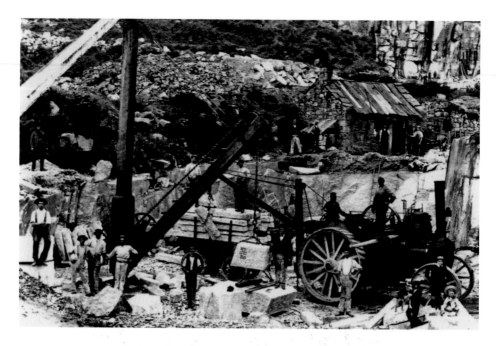

Maen Quarry

One of Freeman's quarries believed to be Maen where everyone stops work (including children, bottom right) for the photographer to take this picture of numbered granite blocks, using dog hooks and timber derrick to lift them, while the steam traction engine is employed in storing what looks like kerb stones. The shed in the background could be the blacksmith's shop where repairs were made to broken chains and to sharpen tools, etc. Another Freeman's Quarry Polkanuggo, employing at one time ninety men. At a time when steam cranes were used as early as 1900 to lift huge granite blocks from the quarry to the mason's working area, the photograph shows a crane being used, with dressed blocks around the ground. The workmen have stopped work to have this photograph taken in around 1900.

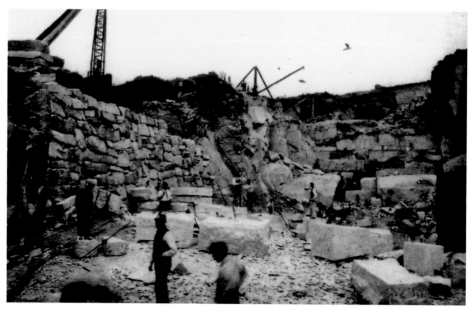

Lambeth Bridge

This huge piece of granite has been dressed and craned into place at Lambeth Bridge London, *c.* 1920. Brought from Penryn by sea, these blocks of granite in great perfusion of size and shape were used for two new bridges. On the Putney Bridge, stones can be seen with markings to ensure they are in the correct position. Lambeth Bridge used 110,000 cubic feet and Putney 128,000 cubic feet. Can you imagine the scene by the river, the tooting of the river tugs, the grunting of the motor buses and the general hubbub of London life overshadowed by Big Ben?

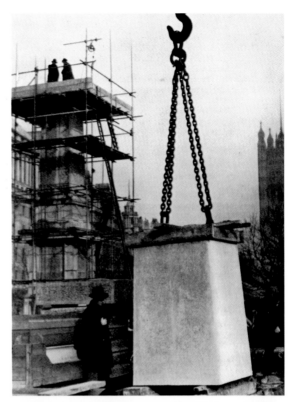

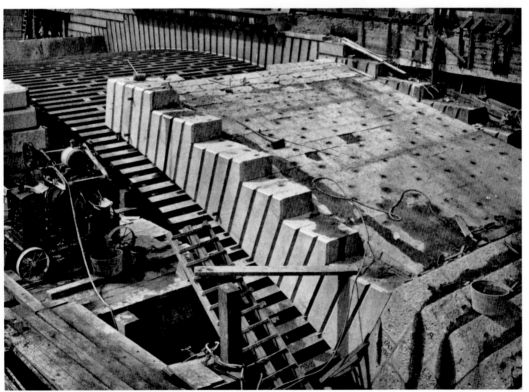

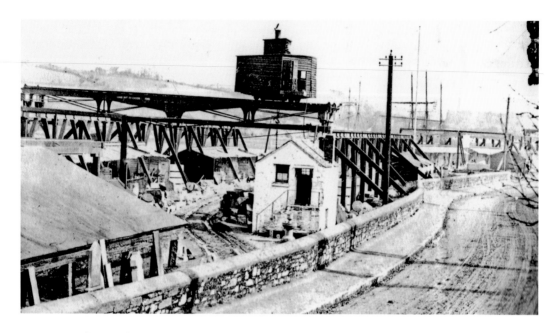

Penryn Granite Works

Penryn granite works or Freeman's yard began in the nineteenth century when the industry was established alongside the Penryn river. With thousands of tons of granite stone coming from the villages around, there were 160 masons employed simultaneously as well as hundreds working in the local quarries. The overhead steam crane was later replaced with an electric one that would take a 15 ton capacity with a travelling gantry of 420 ft and 66 ft span. Every workman was undercover in the dressing sheds so bad weather did not cause any delay. Ships berthed alongside the yard for every kind of granite dressing that was made there from massive quoins for bridges and monumental work to the delicate mouldings of a Gothic window. The only thing in this view, the same as the last picture, is the boundary wall; what was a granite works is now a yacht and boat, Chandler's & Broker's.

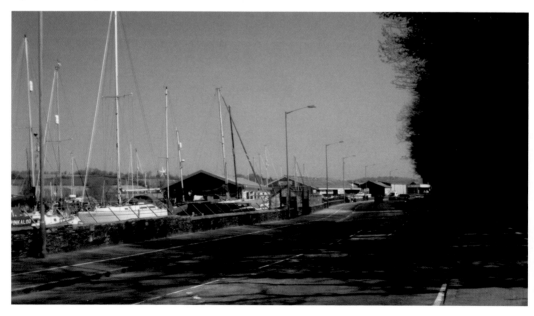

Trenoweth Quarry

Trenoweth Quarry was worked in 1858; Henry and William Opie were there until the 1890s. R. H. Richards & Son worked there until 1925, then Rex and William Pascoe (trading as W. & J. Andrew) took over in 1963 and worked until retirement in 1987. Two years later, the works were occupied by Tim March for monumental and building work. It was the only working quarry in the Carmenellis district. The top picture shows a stone mason at work with old tools, chipping away at a block of granite, wearing protective glasses, smoking, and with what I hope is a shock-proof watch. A modern 2003 Ford pickup truck stands idle outside the old office, with ivy growing up the walls and an asbestos roof.

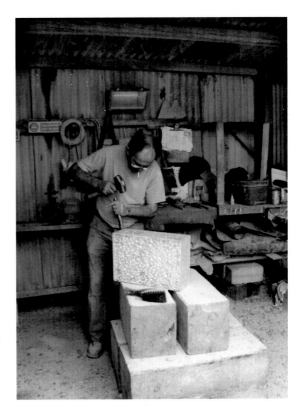

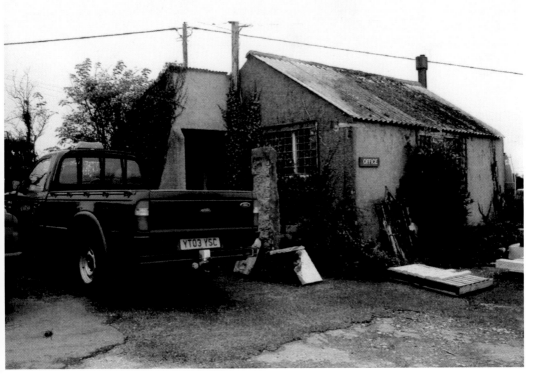

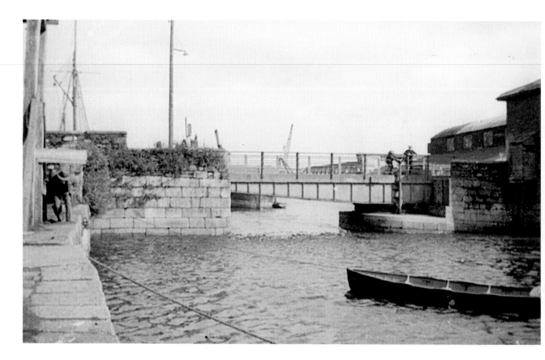

Swing Bridge

This 1920s photograph of the swing bridge at full tide shows it about to open to allow the Coast Line steam barge *Penner* to enter the inner basin and moor alongside the wharf at Budock Creek. This has been a landing place for centuries for numerous cargoes. With the swing bridge opening, the *Penner* is seen entering the Budock Creek; the swing bridge was opened by men operating a gear wheel, taking approximately ten to fifteen minutes to go from motorised transport over the bridge to shipping, going through it with its cargo of various goods.

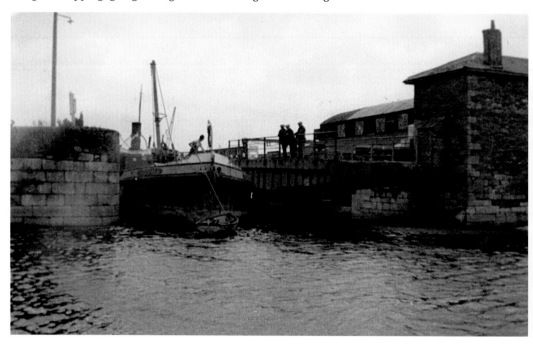

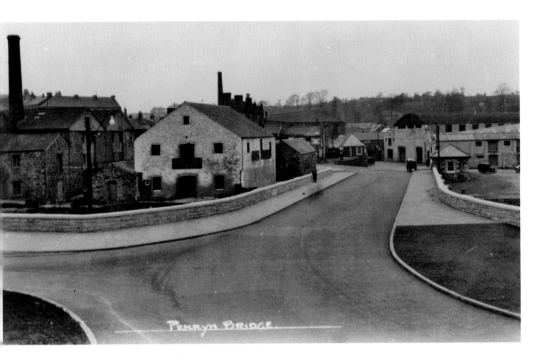

Penryn Bridge

In August 1929, it was noted that over three thousand vehicles with a weight of five and a half thousand tons passed over the swing bridge, and within six years it had doubled. The County Council authorised the building of a fixed bridge, with a width of thirty-three feet, and to widen the road to sixty feet, half a mile from each end. The same bridge as seen today, with new flats and apartments in place of Cox & Co., Anchor Hotel and the Bone and Manure Factory.

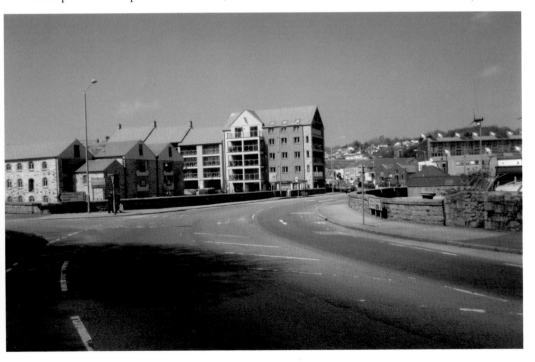

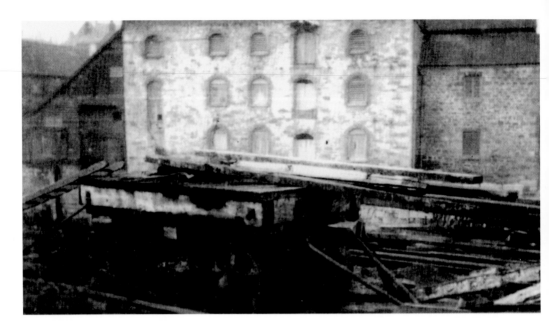

Bone and Manure Company

Both of these pictures are dominated by the three-storey building on the side of Budock Creek. The West of England Bone and Manure Company, due to the revolution in animal husbandry leading to an increase in turnip production after 1820, began to import animal bones and 'guano' to make and supply fertiliser. The upper picture shows the Bone and Manure building in front of which is a trailer usually drawn by a steam engine carrying granite. The lower picture shows the same building after being restored into modern apartments.

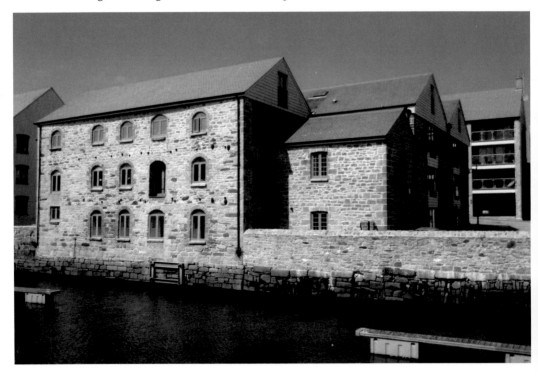

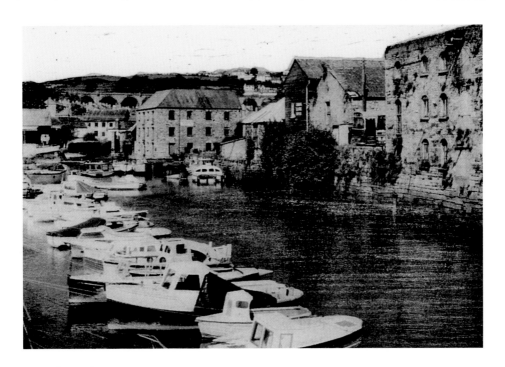

Budock Creek

Budock Creek, *c.* 1970. To the right the three-storey building of the Bone and Manure works has been left to deteriorate, a parked local bus can be seen between the buildings, locally owned little pleasure crafts are moored along the south side of the creek, with the railway bridge visible in the background. With the inclusion of a new building where Cox & Sons ironmongers etc. traded, flats and apartments have marvellous views looking down the river towards Falmouth, regardless of the four horrendous out of place windmills spoiling the vista.

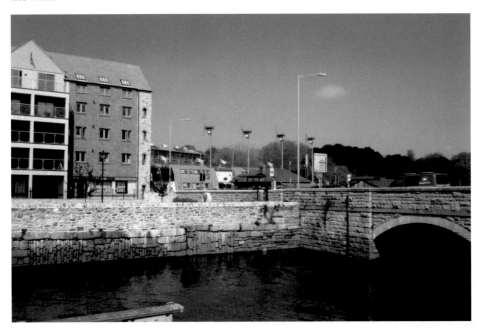

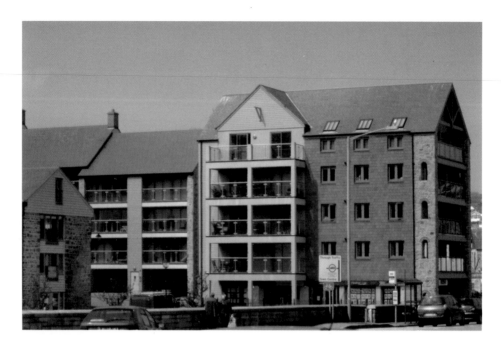

Apartment Buildings

Perhaps a better photograph of the building than the last one, showing the apartments; the building is somewhat similar to the bottom one on page 14, except for the balconies. The signpost says to turn left up Quay Hill to the town centre or straight on along Commercial Road for through traffic. The widened bridge as seen in the late 1930s from a different angle, the photographer could have taken this photograph standing on one of the little ships moored alongside Freeman's works at full tide. Behind the ropes, pulleys and boom can be seen the Cox & Co. building, the Anchor Hotel, and the tall chimney belonging to the Bone and Manure works next to it.

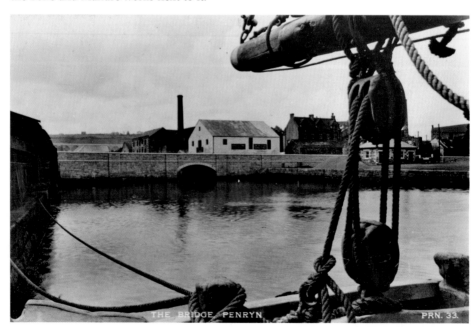

THE BRIDGE, PENRYN PRN. 33.

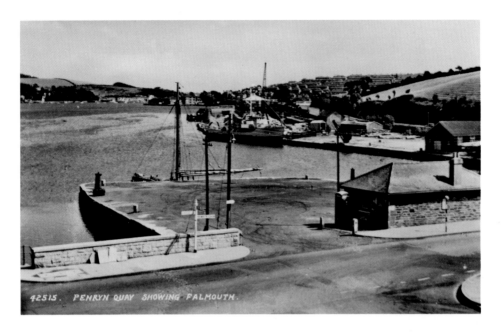

42515. PENRYN QUAY SHOWING FALMOUTH.

Penryn Quay

This could well be the view or similar to what owners of an apartment have looking towards Falmouth. The telephone box has been changed, but the original building on the right still stands. A little coaster is moored along Freeman's Wharf as is a little boat tied up to Exchequer Quay. The signpost says it is two miles to Falmouth and eight miles to Truro. It is a quiet sunny day in the 1950s without any horses or horseless carriages. This is the view you would see if you stood where the coaster is moored in the opposite picture. Moving on fifty or sixty years, you are looking at the back of the works units in Commercial Road. Almost all the buildings still stand; if you look carefully at the building with the brown roof, next to it was where a fire burned a furniture store to the ground and has yet to be rebuilt.

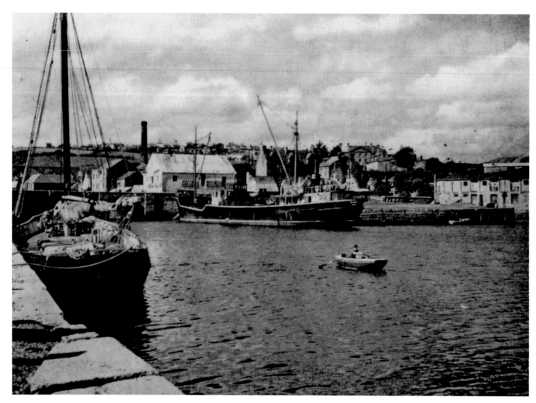

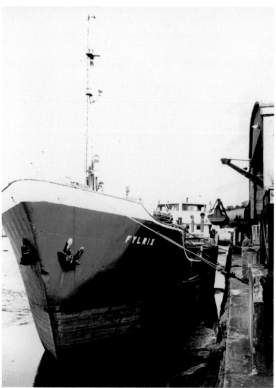

Exchequer Quay

Another view of Exchequer Quay from Freeman's Wharf, looking a little busier than the last ones. The Bone and Manure works, Cox & Co. and the Anchor Hotel are all prominent, as is Annear's coal yard to the extreme right. The coal boat *Fylrix*, with a dent in her bows and sitting on the mud at low tide, having come from South Wales fully loaded, is about to have her cargo discharged by the loaded scoop; this was the very last coal boat to bring coal to Annear's by sea in 1972.

Annear's Coal Yard

A modern view of where Annear's coal yard was. Before it was a coal yard it was a cattle lair; when cattle were imported from Spain, they were made to 'walk the plank' as the sea water was meant to kill any disease they may have had before being driven to the cattle lairs. They were then bought by local butchers and humanely killed. The bottom picture is taken from the rear of J. C. Annear's coal yard; the ships are lying on the mud at low tide, with a single four bladed propeller. Behind the rigging of the ship in the foreground, the muddy beach can be seen, as well as St Gluvias Church.

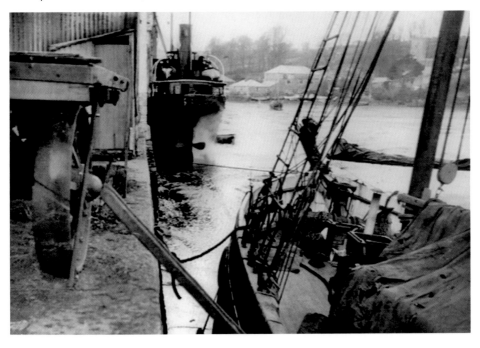

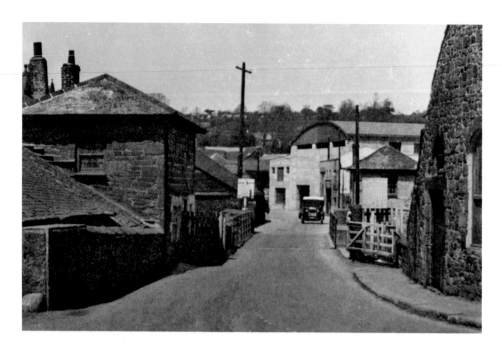

Bridge Improvements

This photograph shows a works van crossing the swing bridge in the late 1920s. It shows how narrow it was, and with the increase of traffic, both horse drawn and motorised, it had to be widened and replaced with a more permanent one. Construction began in around 1930. Commercial Road one end and the Falmouth Road the other were widened, and several buildings were demolished in Commercial Road. Under the County Surveyor E. H. Collcutt, A. E. Farr were the contractors. With T. Greenwood, Penryn's Mayor, present, it was opened on 14 February 1936 by Hore-Belisha. I was the first to cross — my mother pushed me over in a pushchair!! The modern picture shows what it is like now; what a difference.

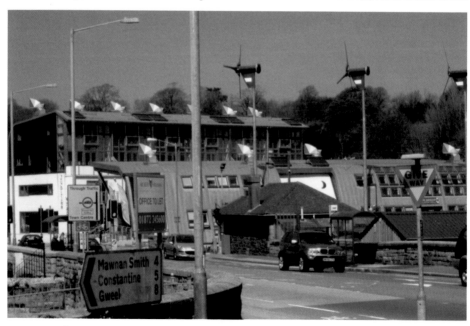

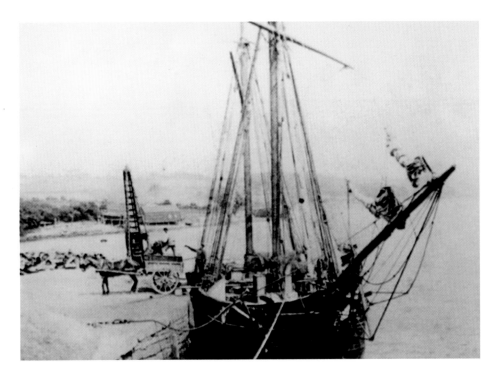

Exchequer Quay

Exchequer Quay at half tide shows a ship being unloaded into a horse and cart; it could be almost anything, from coal to granite, but not anything heavy because the crane in the background is lying idle. These little boats are moored on Exchequer Quay at high tide in the mid-1960s, with an Austin mini van parked near the large cast iron bollard, the latter of which is still there since the nineteenth century.

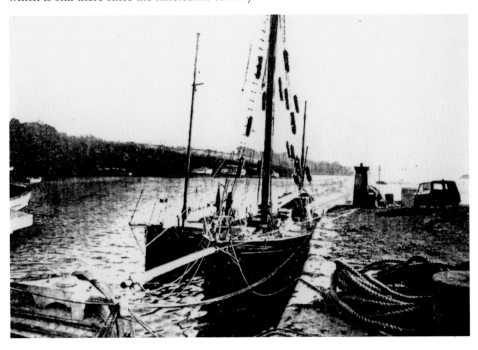

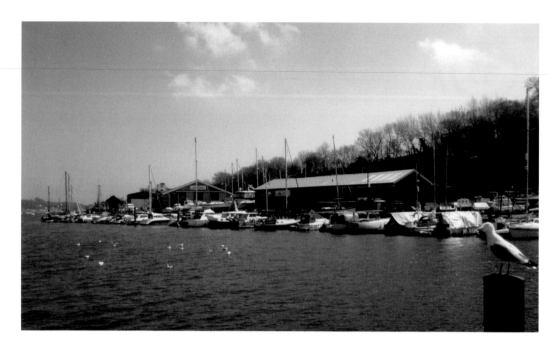

The Quay

This modern photograph was taken from the Quay looking at the boat yard of where Freeman's yard was since approximately 1800 until the 1960s. The seagull could be looking for its next mouthful of food. Taken from the same position as the last with several years between the two, Freeman's yard is seen on the right showing the overhead gantry and steam crane, with several large pieces of granite, meaning the yard could still be working. The large cast iron bollard could have been placed in the same position as its companion the other side of the Quay, but the smaller granite bollard could have been built into the Quay when constructed some 400 years or more ago.

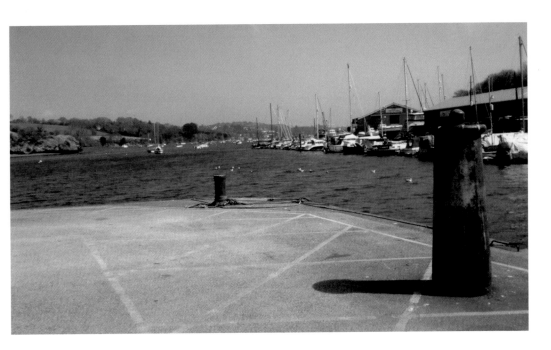

Freeman's Quay

Similar to the last few views, this modern picture, taken once more from the Quay. The yellow grid states there is no parking for modern transport. With the little boats tied up alongside Freeman's Quay, the boat construction/repair company looks very busy. This *Woodbine Funnel* motor vessel moored up alongside the Quay is unloading wood probably for Fox Stanton, perhaps from Norway. The ship is too large to pass through the swing bridge and could only manoeuvre up the Penryn river at full tide. Stevedores are seen manhandling the lengths of wood piled high. In the foreground it looks like a cargo of gravel has already been discharged.

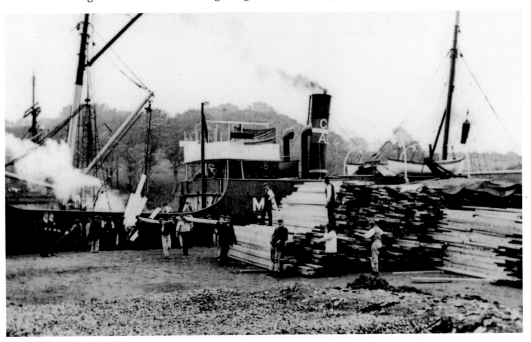

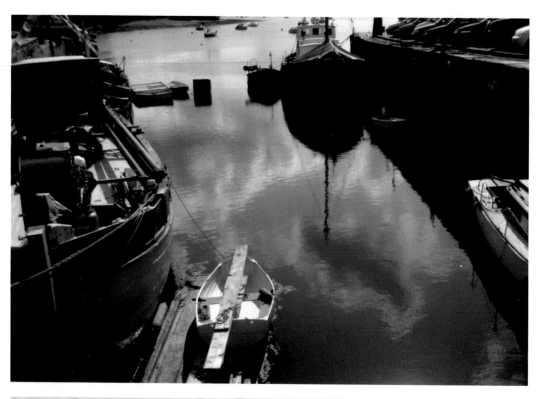

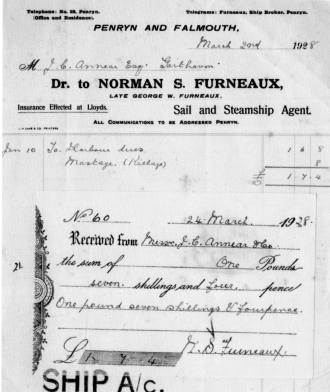

PENRYN AND FALMOUTH,

March 2nd 1928

M. J. C. Annear Esq. Garthavon.

Dr. to NORMAN S. FURNEAUX,

LATE GEORGE W. FURNEAUX.

Insurance Effected at Lloyds. **Sail and Steamship Agent.**

ALL COMMUNICATIONS TO BE ADDRESSED PENRYN.

J. H. LANE & CO. PRINTERS.

		£	s	d
Jan 10	To. Harbour dues		1 6	8
	Mastage. (Keelage)			8
		£	1 · 7 ·	4

No 60 24 March 1928.

Received from Messrs. J. C. Annear & Co.

21. the sum of One Pounds

seven. shillings and Four. pence.

One pound seven shillings & Fourpence.

£ 1 · 7 · 4 N. S. Furneaux.

SHIP A/c.

Norman Furneaux

A picture of where the regattas took place year after year for the entertainment of the local residents, this one shows a reflection of the craft still being used with the old cast iron bollard alongside the modern cars and vans we use today. Here is a receipt and invoice from Norman Furneaux, sail and steam ship agent dated 1928 to J. C. Annear for £1-7-4d (137p approx.) for harbour dues etc. for the motor vessel *Garthavon* for or from the ship's A/c (account). It took twenty-two days to pay. Look at the low telephone number. At one time his office was on the Quay then moved to the Anchor Hotel with Betty Bates and Mary Peters to assist him.

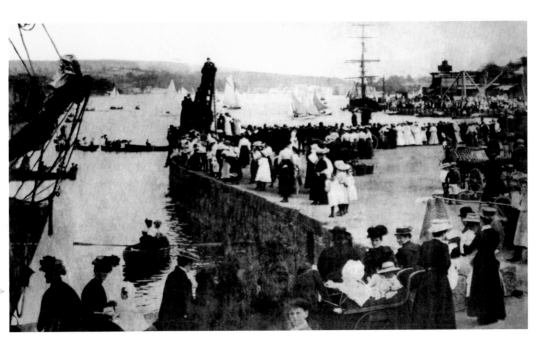

Regattas

This photograph, taken in 1898, shows that the Quay was also used for other purposes; here is a regatta in full swing with yachting in the background, everyone in their finest clothes watching the events, with the ladies in the foreground in their huge bonnets with a lovely Victorian perambulator. Moving on a few years, this photograph shows another regatta; they both seem to be well attended. A yachting race is in progress; someone owns a large steam launch seen over the top of the bridge wall. As well as yachting, there were swimming races, greasy pole and a school swimming competition. Public tea in the afternoon was served on The Green and Camborne town band were hired to entertain the public in the evening of July 1930.

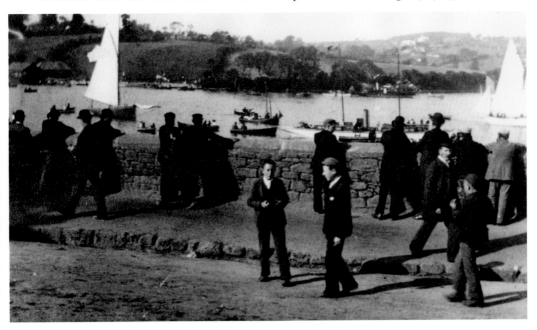

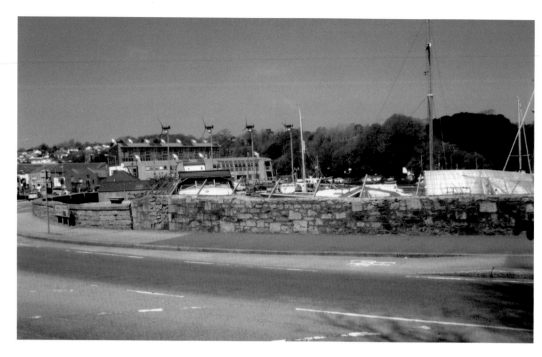

Boats and Bicycles

This modern photograph was taken from the same position. How things have changed; the only thing left now is the wall to lean on. A photograph, *c.* 1890, showing a little ship moored alongside the Quay with two men discussing the state of the economy or the weather. The three wheeled bicycle looks very interesting; it could be one of many makes of that period that were sold by a local dealer, Mr James.

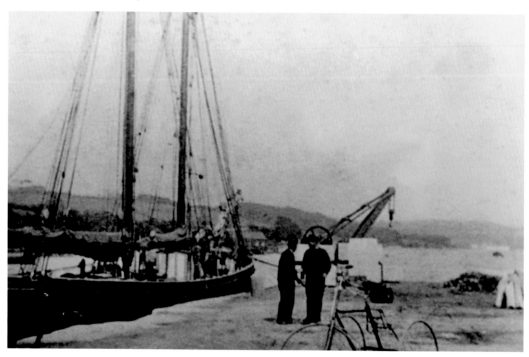

TURNIP CROP

AND REDUCTION IN THE PRICE OF

Bone Manure

❦◆◇◆❦◆◆❦◆◇◆

THE PRICE OF BONE MANURE

MANUFACTURED BY THE

PENRYN BONE MILLS

HAVING BEEN

Reduced to 23s. per quarter

All orders that have been taken or executed this season at a higher rate by

W. F. KARKEEK

TRURO

WILL BE REDUCED ACCORDINGLY.

Cargoes of Bone Manure are now in preparation for the

TRURO. NEWQUAY and PENTEWAN

districts which will be delivered during the ensuing month.

Superphosphate of Lime Peruvian and Ichaboe Guanos and other Manures of known value applicable to root crops are constantly on Sale at **W. F. KARKEEK'S** Manure Store at the LOWEST MARKET PRICES.

Truro April 28, 1847.

HEARD AND SONS, PRINTERS, BOSCAWEN STREET, TRURO.

Penryn Bone Mills
Penryn Bone Mills of 1847 is self explanatory.

From **J. C. ANNEAR & CO.,**

Builders' Merchants, and Coal Merchants,

Commercial Road, PENRYN, CORNWALL.

DATE AS POSTMARK.

SPECIAL OFFER OF COAL EX SHIP.

Please reserve for me....*1*......tons..........cwts of Coal at your quoted price.

*1.—~~I will send for the Coal.~~

*2.—Please deliver the Coal.

Name......*Jethro Bath*....

Address......*South Rd*......

......*Stithians*..

*Please strike out which does not apply.

Annear & Co.

Annear & Company had a yard to the right of where the photographer stood to take the last picture. The postcard above was sent from Perranwell station in 1927 for one ton of coal. The only address is J. C. Annear, Coal Merchants, PENRYN (no road name, no street number and no postcode). Cox & Son Plumbers, Water and Sanitary engineers, were one of the oldest firms in Penryn. They began in the 1890s, with horse-drawn wagons, and would deliver oil in drums to shops and country houses, later moving to motorised transport. The family business closed in 1967. The building behind is the Anchor Hotel, used by travelling businessmen and locals for social occasions. St Gluvias Cricket Club held their annual prize giving there. In March 1985, the Landlord Patrick Overran locked the front door of the freehouse for the last time after an official of Carrick Council said 'if a lot of people were having a jolly sing song, stamping their feet and jumping up and down, the loading would transfer to the gable end wall and it would affect the stability of the building'. The building opposite was, at one time, a pair of cottages, which were later demolished.

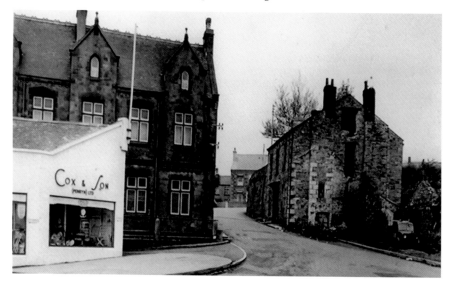

Quay Hill

The Bone and Manure building is derelict, and Cox & Sons showrooms and the Anchor Hotel have been demolished. The signpost is the only clue of how to get to the town centre when this photograph was taken at the corner of Quay Hill. A modern view of the same area, which shows only the signpost remains, traffic lights have now been added and yellow lines have been extended. New apartments have been built, giving wonderful views down the river.

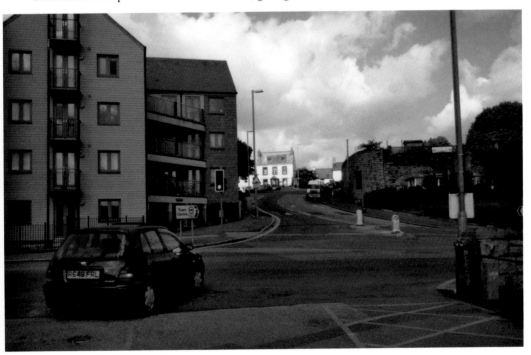

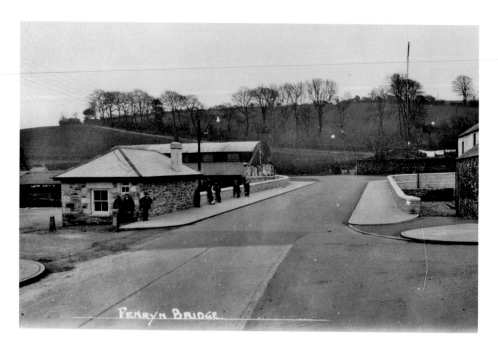

Harbour Master's Office

This postcard by Hawke of Helston was taken after the new bridge had been built and opened, with the opening to the Quay on the left, next is the Harbour Master's office, the next building belongs to Freeman's, and crossing the road there can be seen Cox & Co. showrooms and the turning to the town up Quay Hill. In the same spot where Hawke took the last picture, an extension has been added to the Harbour Master's office, and changed to a café. Traffic lights and keep left bollards are now prominent. Traffic has built up, waiting for the green signal to go. Freeman's building has gone and is now a yacht chandler's business.

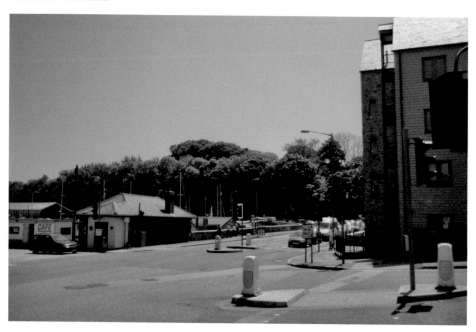

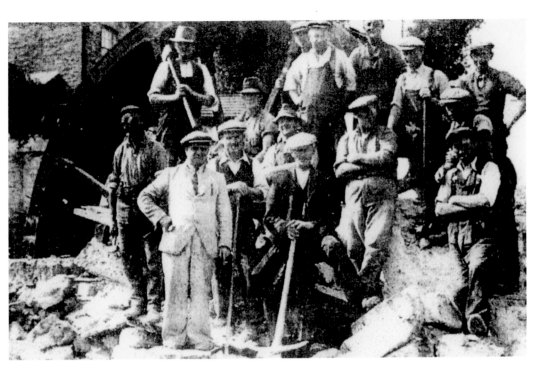

Road Widening

In order for the bridge and approach roads to be widened it was necessary to demolish all types of buildings; here we see the Paper Mills belonging to Mr George Read being demolished, with the workmen taking a break to have their photograph taken. A. E. Farr were the contractors to do this work in around the 1930s. Taken from the same place, it shows the end of the bowling green wall, where traffic lights and bollards have been added. The blue painted premises are now self storage units, and to the right is a listed building, once garages belonging to Penryn & Falmouth Motor Bus Company.

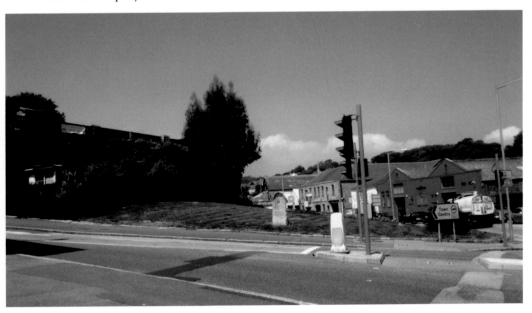

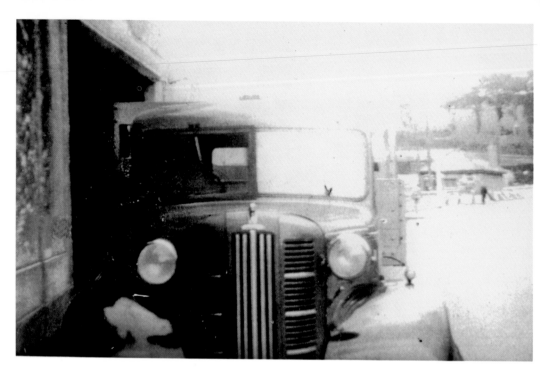

Annear's Coal Yard

Parked outside the premises of J. C. Annear, this 1948 Austin two ton lorry, with a split windscreen and electric lights, waits for a shipment of coal to be loaded. Standing near the trees in two pictures ago, here is a photograph of where Annear's coal yard was on Jubilee Wharf; before that it was the cattle lairs.

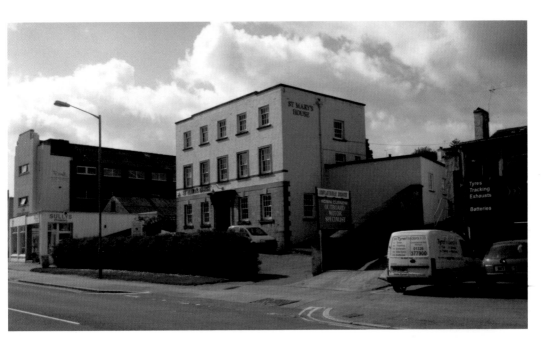

Old Police Station

The main prominent square building was the old Police Station, now named St Mary's House. To the left is a picture framing business, behind which stands the classic front of a builders merchant, to the right a long established firm of outboard motor specialists Robin Curnow, the tyre finders, and motor accessory firm. On 6 August 1977, the Queen stopped on her Silver Jubilee tour; she is seen here with the Duke of Edinburgh, being greeted by the Mayor, Mr Bedford-Daniel. Also in the picture is Reg Chegwidden, Dickie Dunstan and other Penryn dignitaries. What is Harry Secombe or Les Dawson doing with the Penryn Mace? In fact it is Jack Young.

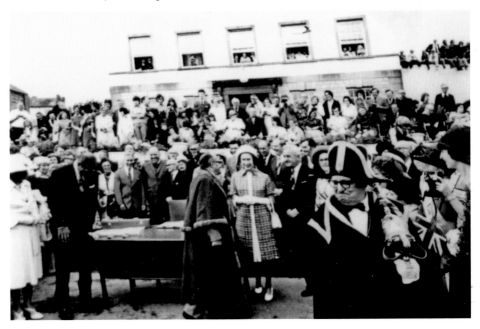

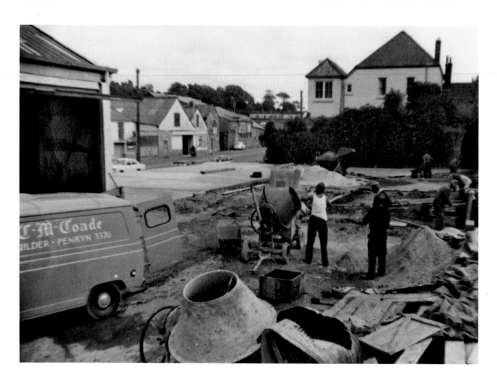

Commercial Road

Colin Coade, the local Penryn builder, is building new premises here in Commercial Road. The worker attending the mixer has taken his jumper off and it is lying on the cement mixer in the foreground. The large building on the right is the Masonic Hall at the bottom of New Street. Standing on the pavement in front of the Job Centre, the premises on the other side of the road, as seen in the top picture, have been demolished and replaced with other buildings. The Freemason's Temple is still there and even after a large number of years the windows are still the same ones.

St Gluvias Creek

This photograph of the end of St Gluvias Creek shows the chimney of the smelting works has been levelled. Stephens no longer exists and the same building has a level roof, not as the picture below. The same creek, taken a long time before the new one, with a forest of masts in view, also the high chimney of perhaps the Saw Mills or even the last smelting works for tin ore, and at low tide the little ships lie resting on the mud.

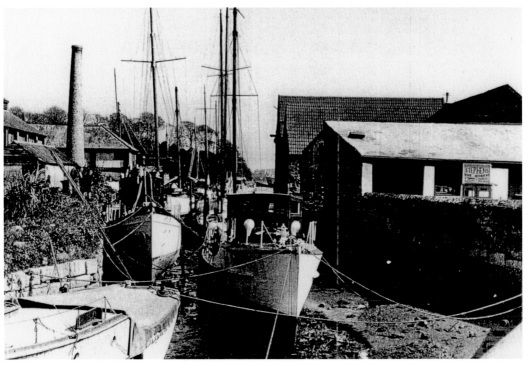

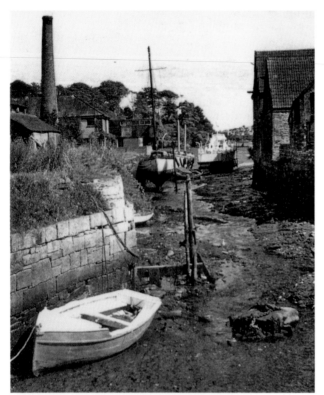

Smelting Works

Perhaps taken in the same time period as the last one, this still shows the chimney standing; the smelting works was the last to be built in Cornwall and lasted until the mid 1930s. It shows the disgusting state of the river, with the vegetation left to grow wild and rubbish thrown everywhere. Spin around to the right from where the last one was taken, and in this modern photograph is Prospect House on the left. In the centre of the background is the Town Clock Tower, built in 1839, and to the right further is the Nunnery; the convent was used as a boarding school for Catholic children and a day school for the poor children of Penryn in around the 1850s. The large building in the foreground to the extreme right is the telephone exchange.

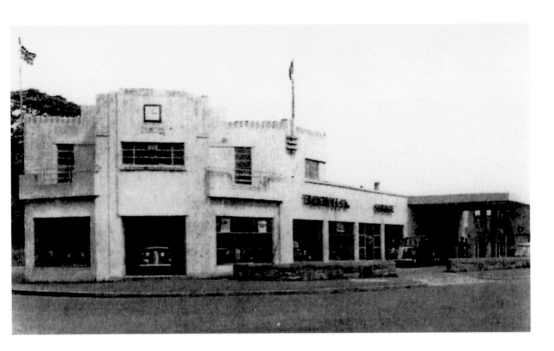

Just Delights

Austin, Rover and Wolesey dealers T. H. Nicholls were also repair specialists when this photograph was taken mid 1947/8; they also sold petrol. This large impressive building in Commercial Road was previously owned by the Richards Brothers, and before that it was owned by the Rundles. Around the corner to the left, the road leads to Mylor and Flushing, and also to St Gluvias Church. Taken from outside the telephone exchange, this is what replaced the garage above. The new business now is named Just Delights. It offers a unique range of vintage and reproduction furniture and a variety of household accessories and soft furnishings to make your house a home. I wonder if it is the same square clock as when it was a garage?

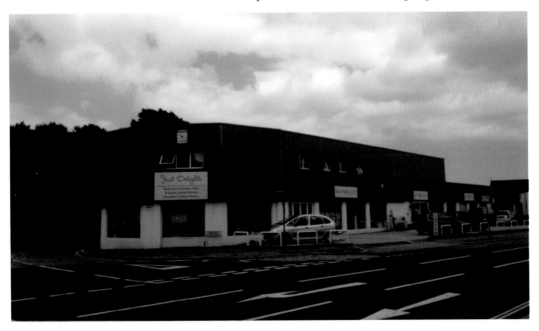

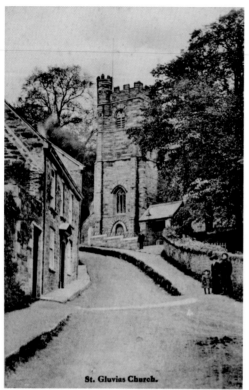

St. Gluvias Church.

St Gluvias Church

Built on earlier foundations, perhaps as far back as the sixth century, St Gluvias Church was consecrated by Walter-de-Stapleton in 1318. In 1883, the body of the church was restored to the fifteenth-century style. Here we see a group of people waiting for the photographer to set up his camera in around the 1930s. Below is St Gluvias Church from the front with a lynch gate to the right. After the Second World War in 1948, death watch beetles were found, the bells became too dangerous to ring and so, with generous donations from two families and a large donation from a single parishioner, new frames were made. The bells were removed and restored by Taylors of Loughborough and one more was added.

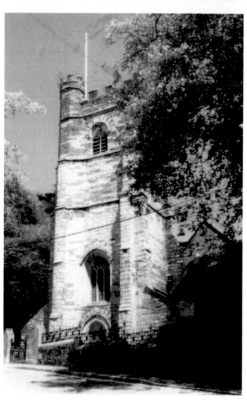

Church Interior

This new colour photograph really shows off the interior at the High Altar of this beautifully constructed Parish Church of St Gluvias with lovely stained glass windows and carved stone and wood; gas lighting was removed and electric lighting installed during alterations in the 1950s. The photographer stands further back and behind the magnificently carved granite font believed to have been made by skilled stone masons from Freeman's of Penryn.

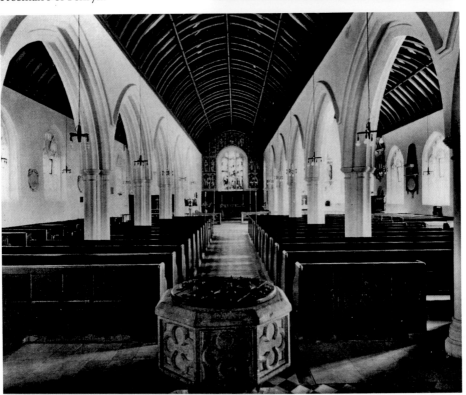

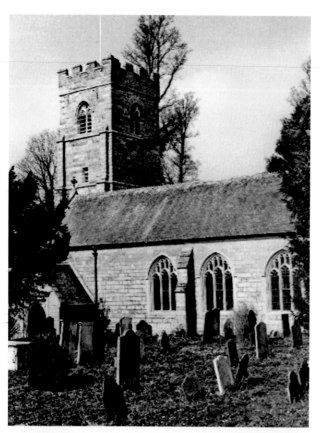

Church Bazaar

From the old graveyard, St Gluvias Church is seen from the south side. This was the church that the Enys family attended every Sunday. At the end of the road to the left of Nicholls Garage the Enys family left their carriage in a coach house (not seen in the picture) during the service, they were collected after the sermon and returned to the Enys Estate. St Gluvias Church bazaar, July 1911. With sunlight shining through the trees, the ladies and young girls look splendid in their long flowing dresses and wearing big hats. Sitting on forms at the trestle tables they really must have enjoyed themselves, tucking into traditional Cornish food and stopping only to have their photograph taken.

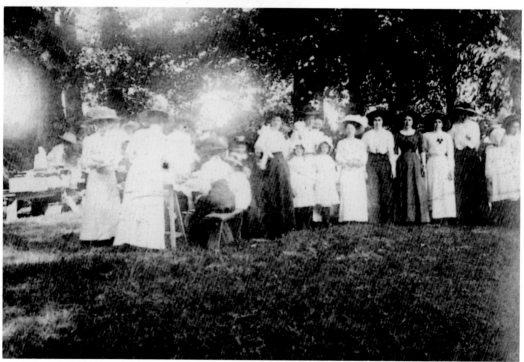

Exchequer Quay

Returning once more to the opposite side of the Exchequer Quay, a stone's throw from the church is man-e-moors muddy beach which as youngsters we were allowed to dig for worms for fishing. King rag were the biggest, so big that some would draw blood with their nippers if you were bitten. The Bone and Manure works, Cox & Co., Quay Hill and J. C. Annear's coal yard can be seen in the background while a man is painting his boat in the foreground at low tide. Not quite the same spot in this new photograph, but near enough, sees a man in his canoe; this scene is to the left of Exchequer Quay.

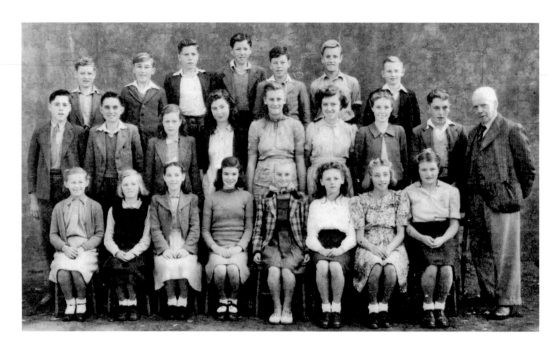

National School

Pupils of the National School 1948/9. Back row: M. Rickard, D. Garland, T. Carlyon, M. Hodge, B. Bate, M. Churcher, W. Dunstan. Middle row: M. Morcom, G. McGuiness, D. Carlyon, M. Arthur, J. Medlyn, V. Hunt, C. Woolcock, G. Collins, Headmaster Tom Gill. Front row: P. Burnett, V. Toy, C. Hocking, E. Hensman, C. Able, D. Terrell, J. Treloar, M. Williams. This new photograph shows the old beautifully carved granite front of the National School at The Praze. The building is now used as a successful antique shop and for clock repairs.

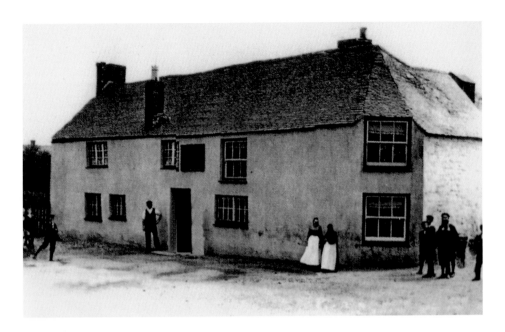

The Cross Keys

The Cross Keys public house, *c.* 1900, at the bottom of Truro Lane (on the right). Estate duty was paid in full following the death of the licensee, Charlotte Ann Edwards, in February 1907. On the affidavit it was described as: 'A dwelling house and premises situated in St Gluvias Street, Penryn, Cornwall, let to Burley and Partner as quarterly tenant together at £10.18s.0d (£10.90p) per annum.' I wonder if it could be her leaning against the wall with another woman, wearing shining white aprons. This modern picture shows that although the windows may have been changed and new ones added at some time, perhaps a new roof and chimneys also, as you can see it is now closed and boarded up. Is it to become a care home? A planning application will be submitted soon to change it into a specialist care home for adults with learning and physical disabilities.

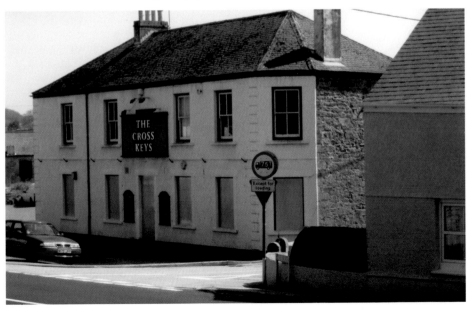

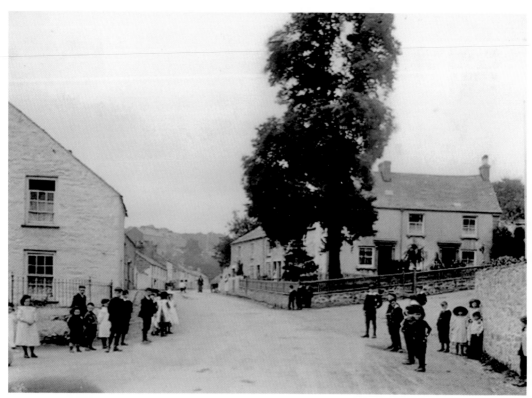

Truro Hill

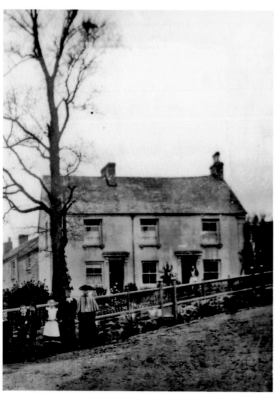

The bottom of Truro Hill showing a large tree, behind which stands a row of cottages; everyone stands still while the photographer sets up his camera. To the left, the building with two windows (one open) was the premises and home, No. 1 The Praze, of Arthur Dunstan and his family, the blacksmith and ex-Mayor of the Borough. In a different photograph of the same cottages that were later taken down to make way for a factory complex, the people outside the fence stand patiently waiting for their picture to be taken.

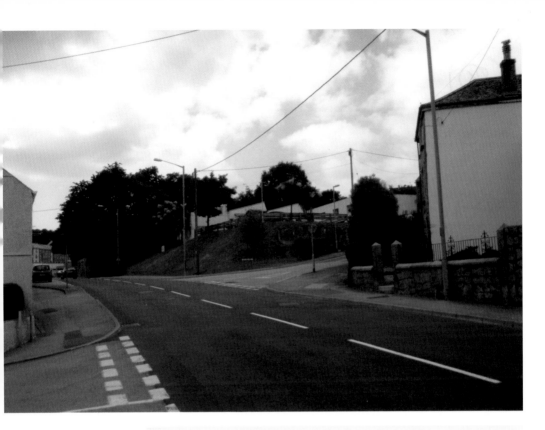

The Praze
A modern picture taken from almost the same position shows The Praze as it is today. No traffic, surprise uprise. An advert that Arthur Dunstan placed in a local newspaper; I do not know why because he was always busy, but he always found time to talk to us youngsters.

A. DUNSTAN

Agricultural and General Smith and Farrier

ACETYLENE WELDING, ETC.

I THE PRAZE PENRYN CORNWALL
Telephone: Penryn 2263

Dunstan's Blacksmith's
Dickie Dunstan's blacksmith's shop; he is seen here at the forge with a young lady and horse, perhaps the horse has already been shod and is waiting for the traffic to ease. His workshop was attached to his home at The Praze. He was Mayor of Penryn 1973/4/5 and Master of the Lodge of Freemasons in 1975. He died aged seventy-seven in 1984. Being interviewed for a television programme, here we see Dickie in his workshop surrounded by his tools; it is a wonder he knew where everything was. He not only shoed horses but he did other repair work as well; a signpost arm for Port Navas is propped against the wall next to an electric grindstone. I do not think his fire will be used for the advertised ox roast.

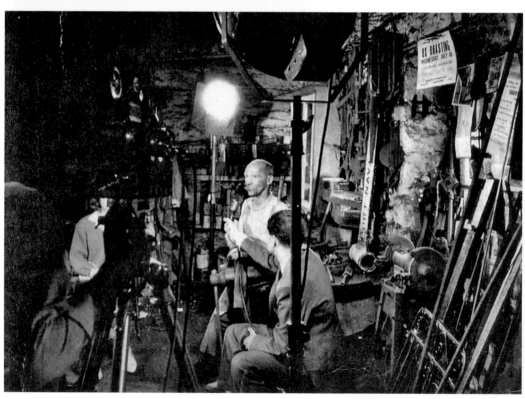

The Dunstan Family

Making a horseshoe on his anvil, Dickie (Arthur Clarence) Dunstan was a very nice and helpful man; his forge, as you would expect, was always dark and dingy, and he had a single electric bulb without shade in his office. Born and brought up at No. 1, he lived there all his life and went to the nearby school. From this recent photograph, it can be seen the blacksmith's shop no longer exists. It closed on his demise in 1984. For years it was a family concern; his father and grandfather owned the business before him. In 1879, an advertisement was placed in the *Penryn Advertiser* offering the business for sale to include a five-year-old cob (a horse) for £50. It was bought by a James Collett; after a short while, William Dunstan bought it back, passed it to Richard Dunstan and, on his death, Dickie inherited the business. They had a daughter Wendy, who still lives at No. 1 and once owned a toyshop in the main street. Now her undivided attention goes to St Gluvias Church.

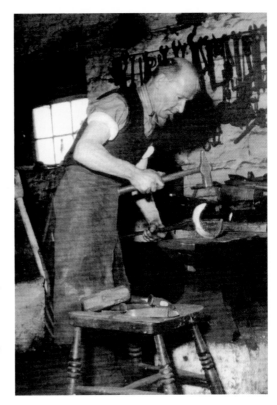

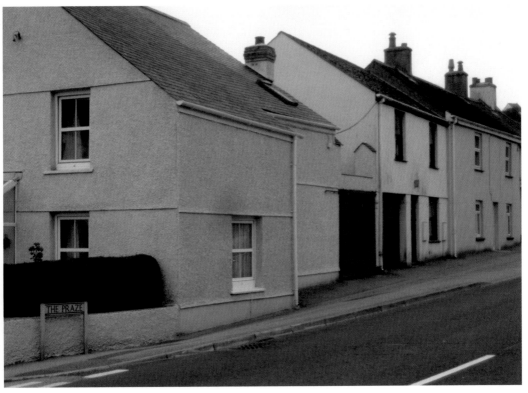

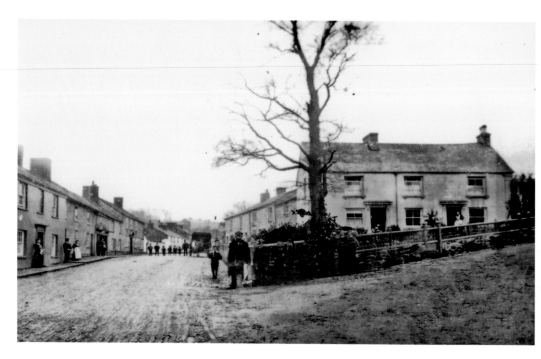

Park and Hill

Standing outside the blacksmith's shop, the camera is pointed towards the park area on the left and Truro Hill to the right. It was up this hill that the mail coach would go to Enys Estate, then Carclew house and on to the Norway Inn to change horses. A more recent photograph of The Praze in 1979 shows two workmen are busy in building a boundary wall, again from solid granite stones, and also widening the road to make the corner bigger.

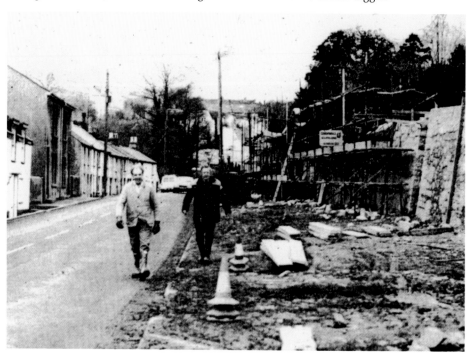

Telegrams—
" Rickard, Laundry, Penryn "

Telephone Nos.
Penryn 7. Falmouth 42

Falmouth and District SANITARY STEAM LAUNDRY

Office and Works:
THE PRAZE, PENRYN, Cornwall
On Main Road No. 39 Truro to Falmouth

Branches—
FALMOUTH TRURO NEWQUAY

Agencies—
CAMBORNE HELSTON ST. AUSTELL

Falmouth and District Sanitary Steam Laundry
Although this advert states Falmouth and District Sanitary Steam Laundry, as you can read the office and works were at The Praze on the main Penryn to Truro road. The company also did dry cleaning and steam carpet beating. The manager was Pearce Rogers. The large van that was used to collect and deliver was an 18hp Lacre with a lovely Cornish registration, AF571. This next photograph shows the children's play area which used to be the tennis courts. Taken from outside on the main road, it shows how large the trees have grown.

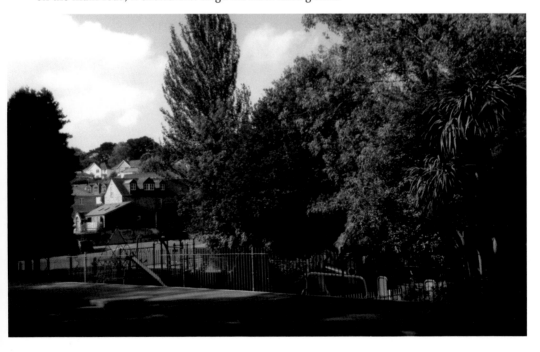

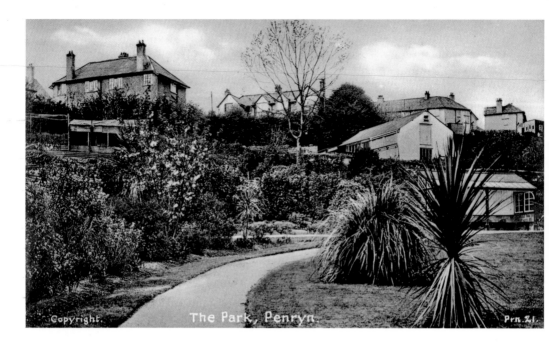

Trelawney Park

Trelawney Park on the boundary between Commercial Road and Browns Hill; previously known as Durggan Moor, it was first thought of as far back as 1924. It was leased to a Mr Martin from J. B. Mitchell as a small holding for growing fruit and vegetables with a deep narrow stream running through it. This postcard shows part of the park with council houses behind Browns Hill. Mr Martin started and paid for a petition against Penryn Council buying Durggan Moor, as he would lose his income. Even the Mayor C. W. Andrew asked the rate payers not to sign, even though the council had been looking for a piece of land to turn into a tennis court and pleasure area, thinking it would be too expensive and the rate payers would have their rates increased. This picture shows Browns Hill in the background and Hawkins Garage.

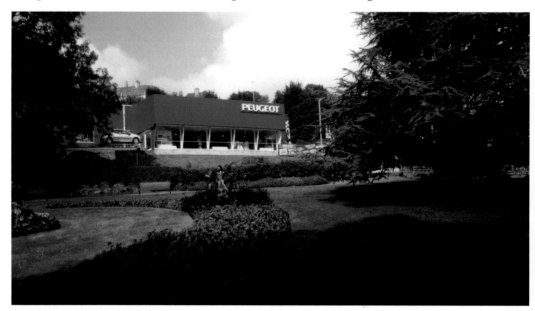

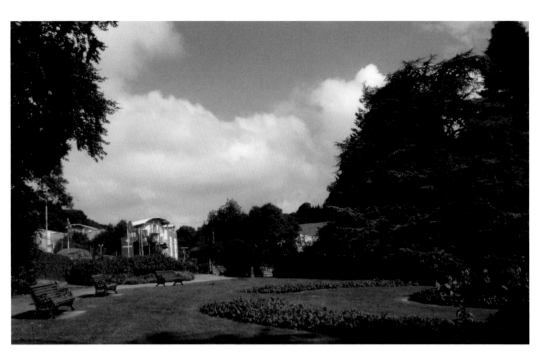

The Green

The council already owned a piece of land named The Green (where the bowling club is now). The former was reopened on 1 August 1925 by C. W. Andrew; football was prohibited, even after some members of the council said that the rate payers were against the scheme. Of 3,000 inhabitants, fewer than 100 signed the petition. This picture shows another part of the lovely park. The following image is similar to the last with a couple of old gentlemen taking a stroll, looking at the plants and shrubs. The Durggan Moor site was given to the council for the people of Penryn by J. B. Mitchell, after Mr Martin's lease expired.

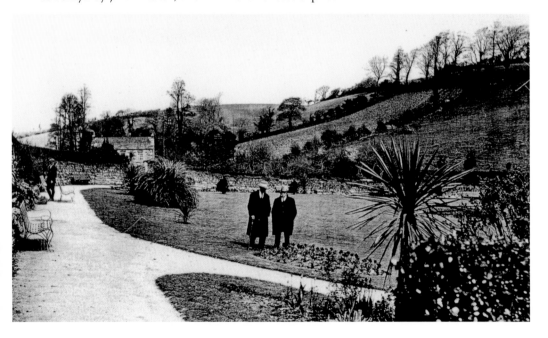

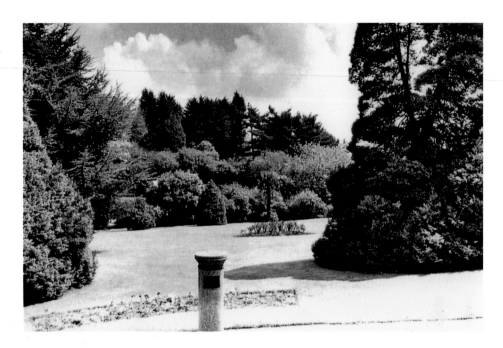

Brown's Hill

A view of the park taken from outside the railings in Browns Hill. The well-kept lawns and trees really are a picture. In the foreground a sundial can be seen (more about it later in the book). In June 1925, the surveyor J. H. Harris stated that conversion of the Durggan Moor site to a tennis court and pleasure ground would cost £340 in laying out grass and to construct hard tennis courts. £300 had been allocated from a will of Joel Mitchell, an ex-Mayor in around 1885. Taken from the top end of the park, this photograph looks towards Browns Hill and the old creamery. Owing to the death of his son, the opening of the park was postponed for a week. Trelawney Park was officially opened by the Mayor Alderman C. W. Andrew, JP, CC, on 5 May 1926 at 7 p.m.

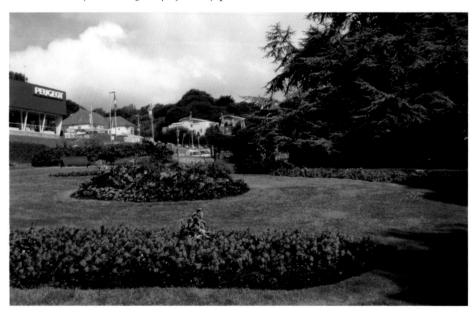

Trelawney Park

If the children don't use the modern equipment, the young good-looking mothers do. Imagine the procession marching through the town headed by the town band, then the Mayor, C. W. Andrew, Sergeant at Mace, and the rest of the council dignitaries, followed by the fire brigade and police, the children from both schools carrying flags, students of Miss Spargo and Mr Tom Gill. With the park opened and the tennis courts laid, Dr N. Blamey and his party played doubles and found it very exhilarating. With Commercial Road in the background, the court can be seen (hardly Centre Court at Wimbledon), but two boys seem to be playing cricket. At a council meeting the first groundsman elected was E. H. Chegwidden, an ex-serviceman with a wife and two children. Later, a notice was placed in the local paper asking people to respect the park and not to damage it in any way!

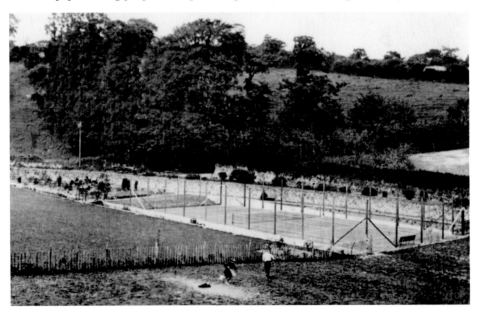

Penryn Creamery

Penryn Creamery at the right fork approaching 'The Borough' from Treluswell on the Truro road. This modern photograph shows the works being demolished to make way for new housing. In the 1950s, Mr Murphy was foreman, with Douglas Young, his charge hand. Others that worked there were S. Nichols, N. Jewell, R. Stribley, L. Jeffrey, and F. Legasick. The drivers of the lorries were J. Newman, R. Smith and J. Bate. I can remember as a youngster climbing over broken bottles looking for the colourful cardboard tops. Now look at it – all gone but the memories of what it was like; when the milk was delivered the foreman Douglas Young would lift the lid of the churn, not only would he smell the condition of the milk but would know which farm the milk came from. No wonder his nickname was 'Sniffer'.

THE COMMERCIAL, SHIPPING & GENERAL
ADVERTISER
FOR WEST CORNWALL.

PRINTED AND PUBLISHED BY J. GILL & SON, AT THEIR OFFICE, LOWER MARKET STREET, PENRYN.

No. 1607 PENRYN, MARCH 19th, 1898. GRATIS.

Mallet and Son

A copy of the *Advertiser* dated 1898. How many people knew Mallet and Son the Truro Ironmonger's had a branch in Penryn that also sold bicycles and accessories, closing in 1909? Tea and butter sold by Head at 10d (5 new pence) a pound. Happy Days!

55

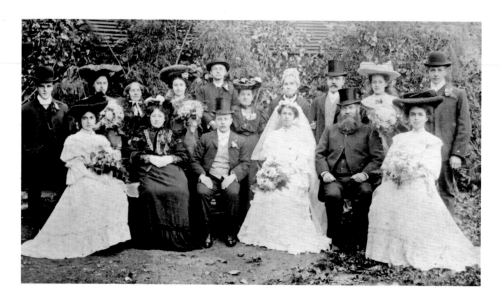

Wedding Days

This really wonderful old photograph of Frederick Dunstan and Beatrice Coplin is believed to have been taken in the rear garden of a large house in West Street in 1905. Everyone wore a hat except the bride, the men either a top hat or a bowler hat; take a special look at the ladies' head gear, the size, the shape and perhaps the weight of some of them. In the photograph is, top row: -?-, Caroline Coplin, Grandma Coplin, Mary Coplin, Grandpa Coplin, -?-, Mrs Fred Dunstan, Mr Fred Dunstan. Sitting: Mary Coplin, Peter Coplin, Jane Coplin, Phillipa Coplin, Frederick Dunstan, Beatrice Maud Coplin, Peter Coplin (father), Phillipa Jane Coplin. Just after the war, in 1948, when this wedding below took place, the reception was held in the Welfare Hall, West Street. (I hope you can follow.) Back row, left to right: R. Dago, P. Bennett, R. Toy, M. Toy, Captain's wife, Ship's Captain, Gunnar S. K. Orge (groom), -?-, Nancy Toy (bride), -?-, -?-, -?- (seaman), B. Toy (bride's father), four Norwegian shipmates, J. Toy (grandfather). Front row: T. Martin, W. Toy, B. Toy (bride's mother), G. Toy, M. Toy, T. Simmons (grandmother).

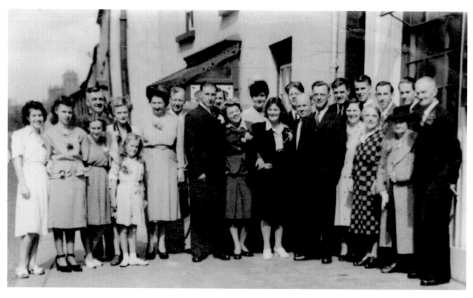

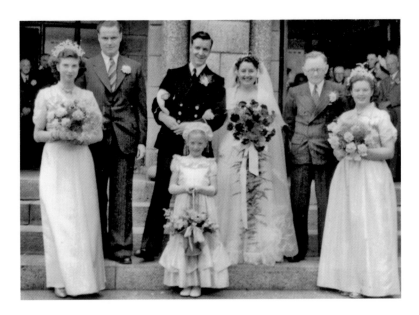

Wedding Celebrations

Standing on the steps of the Wesleyan Chapel (Methodist Church) this is the wedding of Nancy Thomas and Peter Christophers in 1952. Their reception was at the Welfare Hall West Street for forty guests with the honeymoon taken in Paignton. Peter was a second engineer with the British Tanker Company; they are, from left to right: Mr and Mrs Ivor Christophers, Mr and Mrs Peter Christophers, Thomas Thomas (bride's father), Gwen Roberts, the flower girl was Margaret Thomas (sister). Below Mrs Lucy Newby (*née* Nicholls) stands proudly with her husband Lieutenant Christopher Newby, RN, after their wedding at St Gluvias Church, with Cannon Harris officiating, on 8 May 2010. The bride looks radiant in her full length wedding dress with train and tiara, carrying a bouquet of roses and carnations. The groom is in his dress uniform, carrying a dress sword, supported by his best man Lieutenant Commander Andrew Watson, also in his dress uniform and sword. The three bridesmaids wore fuchsia pink dresses and accessories with flowers to match their dresses. They are, from the left: Andrew Watson (best man), Wendy Tregidgo, Clare Farley (bride's cousins), Mr and Mrs Newby, Jess Tregidgo (bride's cousin), on the right is Andrew Nicholls (bride's brother).

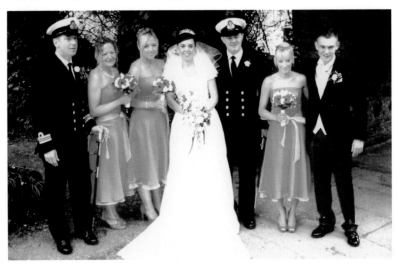

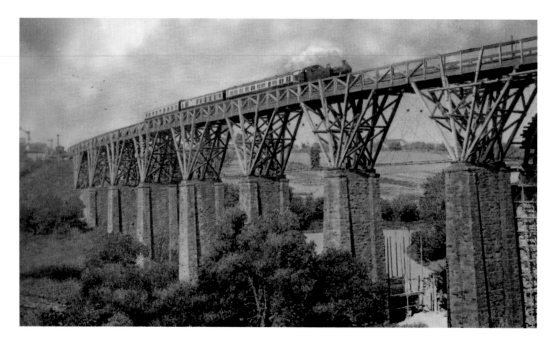

Railway Bridge

Isambard Kingdom Brunel designed and built this fan type wooden bridge supported on stone pillars. It was the last to be built on the Truro-Falmouth branch line over College woods, opened August 1863. With sparks from the steam engine catching fire to the wood and continuous use, the timbers were often renewed. To the bottom right, new piers are being built to support the new bridge in around the 1930s. From this view looking down the Penryn river will be seen the new bridge in place and a splendid sight of the harbour. The old wooden bridge has been demolished, just leaving the stone pillars in place in around the 1950s.

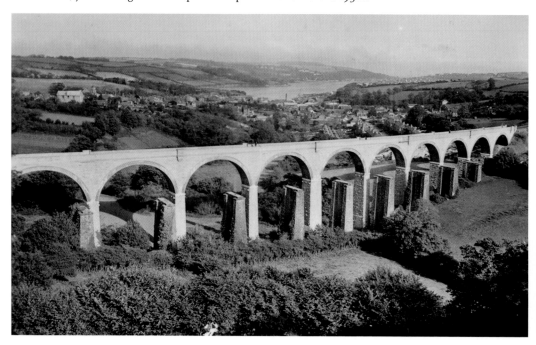

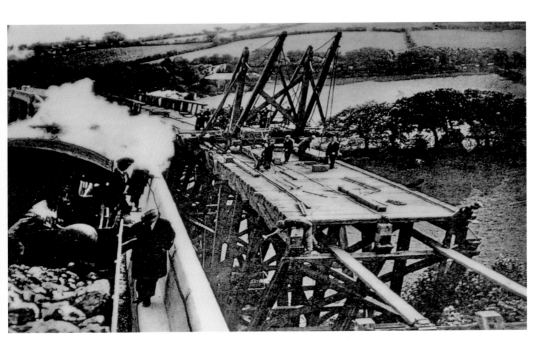

Bridge Developments

With a steam train on the new bridge, this is a photograph of the old wooden bridge being dismantled in the mid 1930s, where several men can be seen working; it probably took as long to dismantle it as it did to build it. In the mid-1880s, when the station was first constructed, the lines were built in the form of an 'S', without a single straight line. A huge rebuilding scheme was implemented in the 1920s which involved moving thousands of tons of earth and soil, which was used to form an embankment replacing the Pascoe viaduct, another one similar to the College woods seen earlier. To the left of the picture, the work looks as if it had been going on for some time.

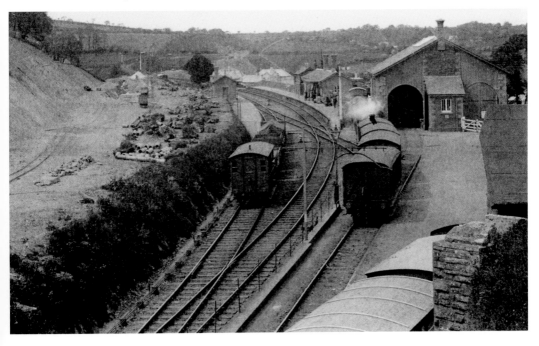

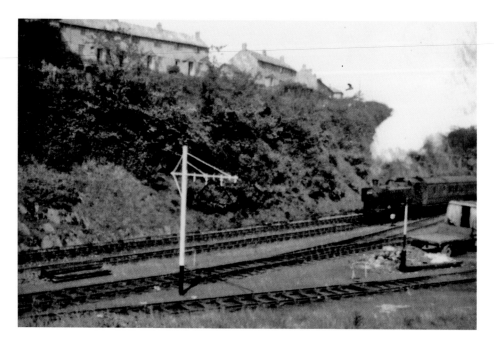

Penryn Station

Taken in the 1950s, this photograph shows a steam engine in almost full power pulling passenger carriages after leaving Penryn station on the down line towards Falmouth. Arthur Pomery was station master, Vic Williams was signalman, and Ivor Dodd was a junior porter, among others. After Dr Beechings axe fell, just about the whole of Penryn station was demolished, including the signal box, and left desolate; it then became a halt. The complex then changed to a car auction site with car boot sales on a Sunday; even so, there are still lovely views down the river to Falmouth Harbour.

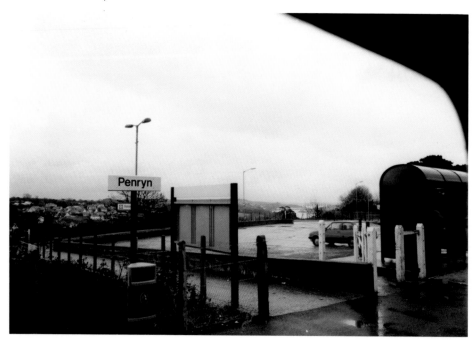

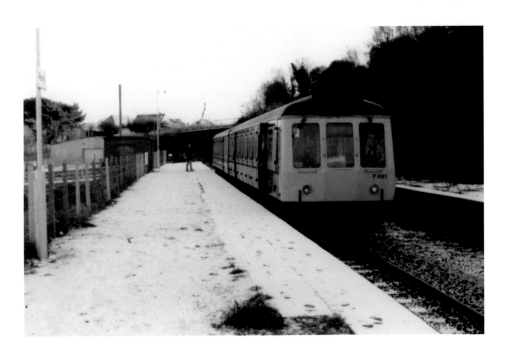

Railway Station

This is somewhat similar to the last, except by now there is only a single track. This would be a diesel train; there must have been a number of passengers that day with the footprints in the snow. Unfortunately with the University coming to Penryn it was thought necessary to revamp the station. The time taken for a train to travel from Falmouth back to Falmouth was approximately one hour on a single track, named the Maritime Line. To double the number of trains, extend the platform, build a passing loop, put in a large car park and other small jobs, came to £7,000,000 (yes, seven million pounds). It opened in May 2009, coming with a lot of criticism.

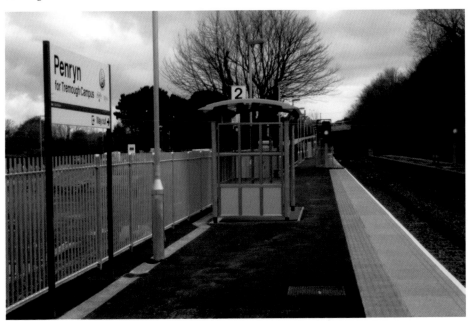

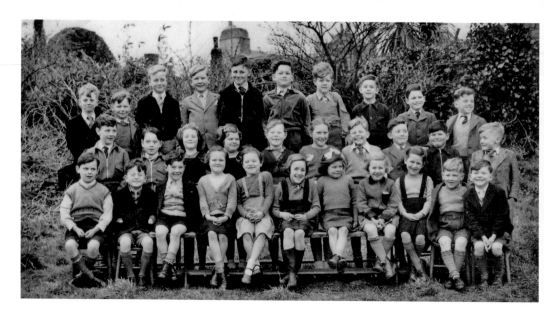

Penryn Schools

Penryn Council School 1949 (Chapel Lane). Back row, left to right: David Collins, David Wills, Anthony Cudd, John Pollard, Franklyn Grigg, Stuart Hutchins, Harry Barnes, Colin Young, David Eva, -?-. Middle row: Terry Coplin, Michael Boase, Valerie Perkins, -?-, Peggy Penver, Josephine Pellow, Paul Chinn, Michael Jewell, Raymond Weeks, Brian Stevens. Front row: Colin Cameron, Peter Leonard, Ronald Jago, Margaret Odgers, Angela Wells, Carole Pellow, Lulu Cornish, Joan Whitford, Patricia Mooney, Malcolm Simpson, John Walls. Penryn Junior School Class 6RP. List of pupils and staff in the photograph: Teacher Mr Richard Pascoe, Teaching Assistants Mrs Sarah Morcom and Miss Alison Williams MBE. Pupils: Lewis Baker, Zara Blundell, Tom Bowditch, Miles Bowden, Jodi Bray, Brandon Bull, Harry Fehrenback, Ty Gilbert, Jamie Grant, Slaine Hillier, Daniel Hinder, Cloe Hughes, Abigail Lily, Katie Linthwaite, John McShannon, Elleanor Moore, Bradley Murray, Keeley Nash, Libby Pacy, Rebecca Penfold, Daniel Sharkey, Ben Watts, Cloe Watson, Libby Williams-Wilson.

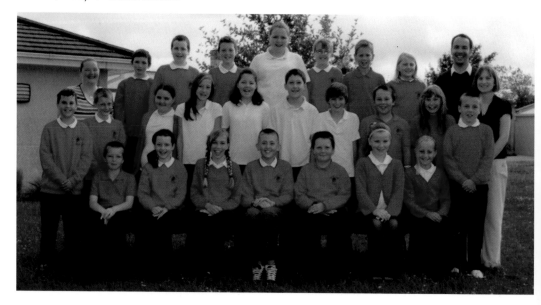

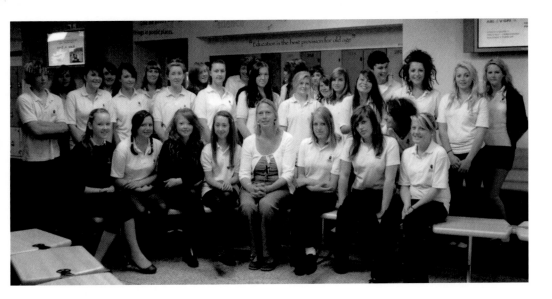

Penryn College

Penryn College Seniors 2010. Teacher Mrs A. Owen. List of pupils: Caroline Barnes, Grace Barnicoat, Bauke Buurma, Max Campbell, Jessica Collins, Brogan Conlon, Amy Creeden, Heidi Dale, Sophie Dugmore, Bobbi Edge, Elizabeth Engledow, Alice Eva, Harry Evans, Polly Hamilton, Olivia Hunter, Bronte James, Genevieve Lovegrove, Alice Martin, Saffron Newby-Nance, Joshua Pearce, Tessa Pengelley, Amber Perrin, Tessa Phillips, Joshua Rollason, Rhona Smith, Emma Snowdon, Kimberley Whiddicomb, Shannon Wilby. Penryn School 1957 at Quarry Hill Falmouth. Back row, left to right: David Row, David Hart, Alex Szewczuk, Stanley Jeffrey, Neil Young, Terry Barnes, David Webber, Michael Webb, Michael Truan, Geoffrey Richards, Roger Hurst, Graham Collett. Second row, left to right: A. Carroll, Jennifer Bowden, Norma Mayers, Josephine Andrews, Joyce Maccuish, Jennifer Whitman, Jill Burns, Jean Hodge, Barry Martin. First row, left to right: Margaret Chevalier, Sheila Tipping, K. Treleaven, Margaret Howard, Janice Harry, Mrs McGrath (teacher), Pat Moore, Norma Clifford, Wendy Cudd, -?-, Pamela Toy, Marlene Timmins. Sitting down, left to right: Lawrence Roberts, Colin Brooks, Kennedy Aitchinson, R. Jenkin, Danny Moyle, Rodney Williams.

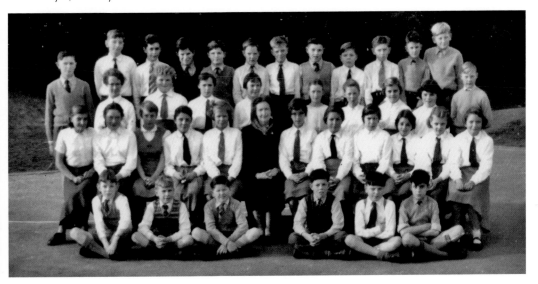

63

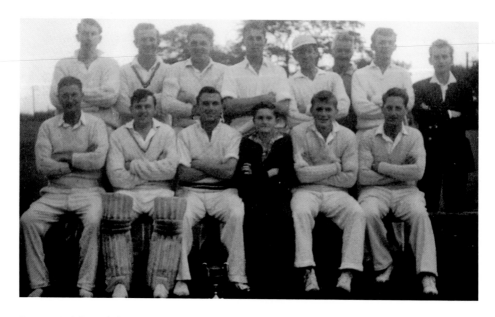

Penryn Cricket Club

Penryn Cricket Club 1961. Played at Parkengue and were champions of Cornwall Senior II division. Back row, left to right: J. Offord, George Wills, Joe Martin, Graham Bate, Clive Willey, Tom Pardon, Peter Toy, Ken Bastian. Front row, left to right: Joe Henna, Gerald Sloggett (wicket keeper), Philip Smith (captain), Neil Young (scorer), R. Smith, R. Bridge. St Gluvias 1st Eleven at Kernick Road, Penryn 12 June 2010 versus Constantine: Back row, left to right: Bill Williams (Chairman), Chris Johnston, Andrew Julian, John Nesbitt, Jake Preston, Neil Pearce, Justin Hosking. Front row, left to right: Simon Bailey, David Connelly (wicket keeper), Matt Julian (captain), Josh Kelly, Gordon Scott. Constantine won by five wickets; no wonder they lost, as Chris Johnston is wearing sandals, Simon Bailey and Gordon Scott have no footwear protection, Josh Kelly plays with one green croc, while the other is between the legs of Matt Julian, (under the bench), the captain, and David Connelly, who are wearing the correct cricket boots; come on boys, 'get a grip' or get M.C. Sports to help you out.

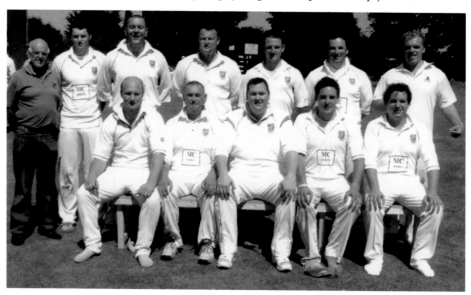

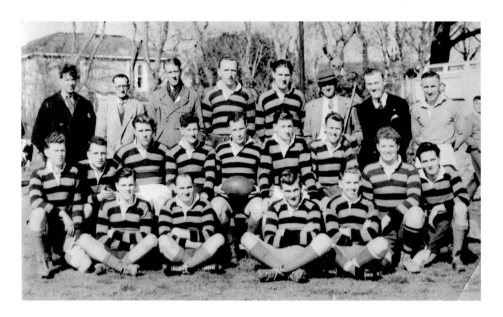

Penryn Rugby Club

Penryn Rugby Club reserves at Penzance, 1948/9. Top row, left to right: Harold George (driver), -?-, Harold Keast (driver), Bert Timmins, Charlie Edney, ? Webb, George Kingdom, ? Thomas (Redruth Referee). Middle row, left to right: Harold Binney, Kenny Jago, Peter Richards, Kenneth Loft, Harry Martin (captain), Bert Thomas, John Binney, Maurice Richards, John May. Bottom row, left to right: Kenneth Odgers, David Thomas, Donald Peters, Sidney Bate. The sponge man, Tom Kennedy, for the first team is on the extreme right next to the referee. Penryn Rugby Club is one of the oldest clubs in Cornwall, formed in 1827, playing at Green Lane. They now play their games at the Memorial Ground dedicated to the men from the club that died in both the world wars. In this photograph are the following players: Back row: -?-, H. Williams, P. Williams, D. Peters, P. Orkney, B. Harrison, S. Bolitho, J. Thomas, R. Harris. Middle row: A. Martin, -?-. Front row: K. Blackmore, M. Smith, D. Laity, D. Thomas, P. Symons, C. Chatterton, C. Toy.

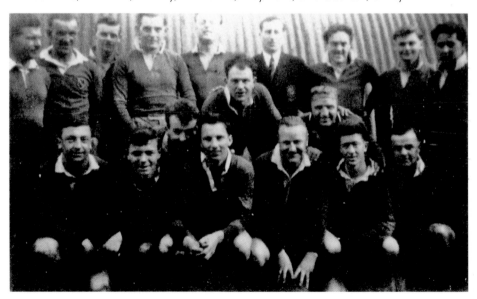

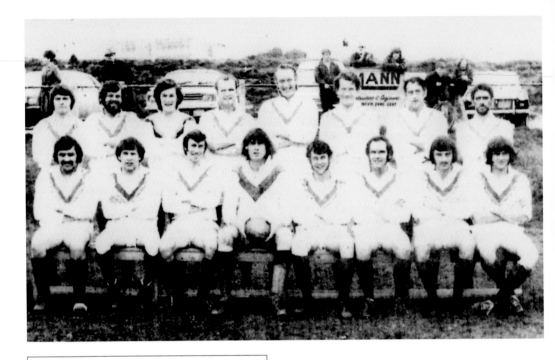

Rugby Club
Rugby Club 1972/3. Cornwall's unofficial Championship Winners, Cornwall Knockout Winners, Cornwall & Devon Cup Winners. Back row: C. Brown, A. Lutey, G. McKeawen, S. Cuthill, R. Glagsher, T. French, P. Simmons, F. Johns. Front row: W. Edwards, G. Thomas, P. Gribble, J. Blackburn (captain), P. Winnan, R. Cameron, M. Triggs, N. Best. Left, Penryn Rugby Official Programme, The Memorial Ground, Established 1872.

Bicycle Travel

On the back of this faded photograph is written Mrs G. Read 1914. George Read was Mayor of Penryn in 1914; could this be his wife? However, the safety bicycle is a lot older, possibly pre 1900, with a spoon front brake, and a Lucas King of the Road head lamp. Here posing with his Raleigh bicycle is Thomas Pearce, complete with flap cap and bicycle clips, *c.* 1912. This machine is a little more advanced than the last one, as it now sports block brakes. At the outbreak of the First World War, Thomas joined up like a lot of other brave Penryn men; unfortunately he was killed in France in 1917.

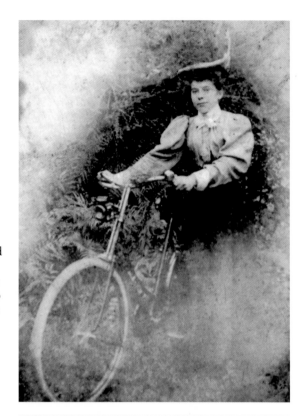

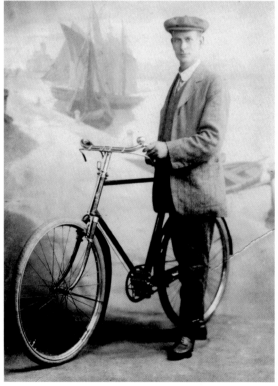

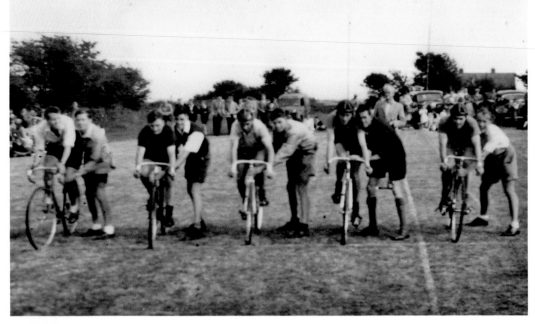

Riviera Wheelers

Riviera Wheelers were a group of amateur cyclists who enjoyed their cycling, and formed in Penryn after the Second World War. Here they are at Mabe in around the 1950s, doing a slow bicycle race. Left to right: -?-, Maurice Bastian, Bill Matthews, William Wright, Eddy Franklin, John Abrahams, George Burleigh, Albert Burleigh, -?-, -?-, John Matthews. It took them a fortnight to do 100 yards! Penryn Freewheelers Cycle Club. With a membership of thirty-forty members, the mountain bikers meet on the internet then drive to where the route or courses are in the Plymouth area each weekend. This year in July they spent two weeks in the French Alps. Their headquarters are in Jubilee Wharf cycle repair shop. Here we see them in France on the Mountain of Hell mountain bike race. They are, left to right, Toby Gardner and Mr and Mrs Wakefield.

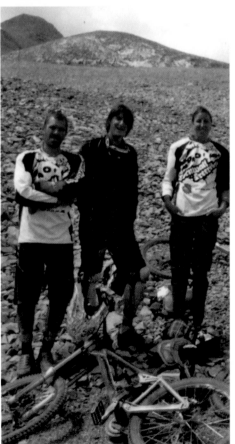

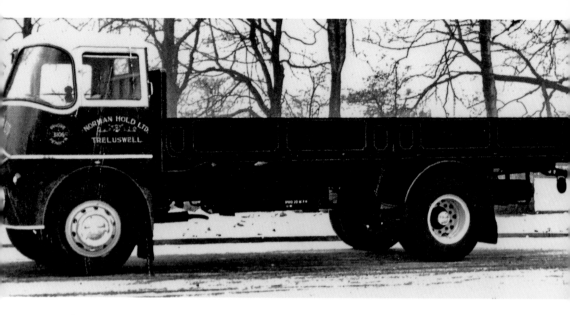

Hold's Haulage

Norman Hold's lorry worked his haulage business out of Treluswell, he was always good to the scouts and would take them many a mile with their equipment to scout camps and return them all free of charge. The lorry in the picture is an ERF, *c.* 1960, the first year when twin headlights were introduced. This coloured card advertises W. J. Easom, as stated, a cycle and motor agent, he was one of the first men in Penryn to own a motor car (see my other books).

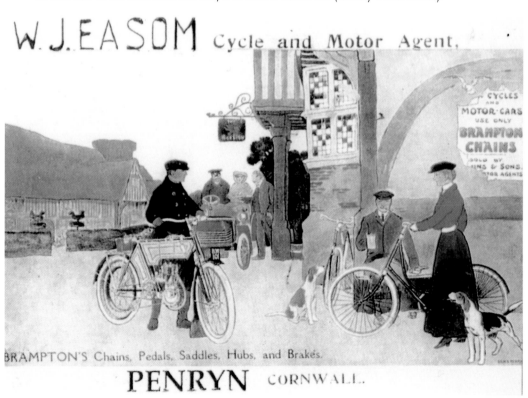

W. J. EASOM Cycle and Motor Agent,

CYCLES AND MOTOR-CARS USE ONLY BRAMPTON CHAINS

BRAMPTON'S Chains, Pedals, Saddles, Hubs, and Brakes.

PENRYN CORNWALL.

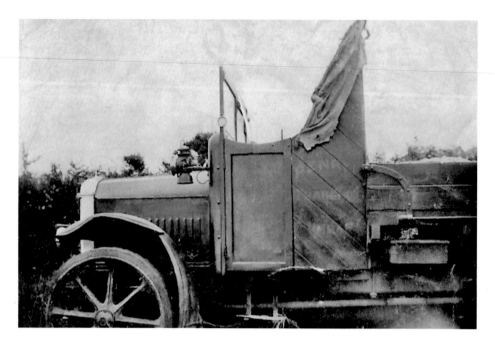

Lorries and Vans

What remains of a 1920s Dennis lorry belonging to the Penryn Transport Company of Treluswell; still running on solid tyres, it has electric head lamps and oil side lights, and from other photographs I believe the registration number was RL 685. CV 7321, this little Cornish registered Morris Light Van, on which there are no windows in the van body sides, but it still runs on steel artillery wheels. The van itself was made in 1930 with full electric lighting, doing approximately 30 miles to the gallon. The vehicle belongs to L. C. Rowse; seen here at Perranwell, in his shop he also sold battery powered radios, and would charge your accumulators for 6*d*.

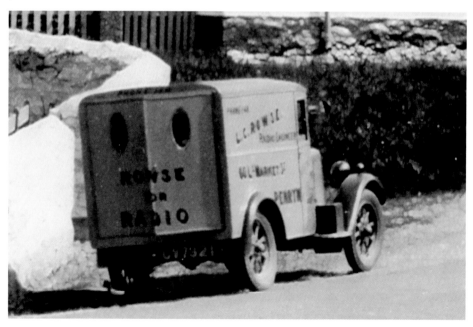

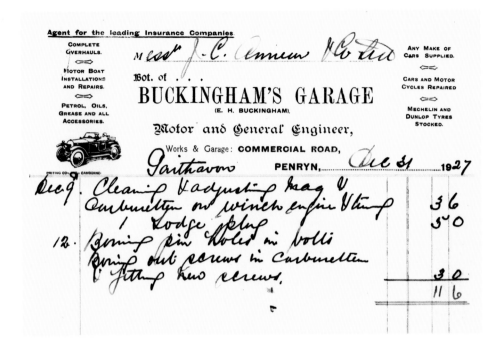

Messrs J. C. Annear & Co Ltd

COMPLETE OVERHAULS.

MOTOR BOAT INSTALLATIONS AND REPAIRS.

PETROL, OILS, GREASE AND ALL ACCESSORIES.

Bot. of . . .

BUCKINGHAM'S GARAGE

(E. H. BUCKINGHAM).

Motor and General Engineer,

Works & Garage: **COMMERCIAL ROAD,**

Garithvon PENRYN, _____ Dec 31 _____ 1927

ANY MAKE OF CARS SUPPLIED.

CARS AND MOTOR CYCLES REPAIRED

MECHELIN AND DUNLOP TYRES STOCKED.

Dec 9.	Cleaning & adjusting mag & Carburettor on winch engine & timing		3	6
	1 Lodge plug		5	0
12.	Boring pin holes in bolt Boring out screws in Carburettor & fitting new screws.		3	0
			11	6

Buckingham's Garage

Buckingham's Garage not only worked on cars; here is an invoice for working on a ship, *Garithvon*, belonging to J. C. Annear in 1927. For:- Cleaning and adjusting magneto and carburettor on winch engine and timing. Lodge plug 5/- (they were expensive in those days; I remember them being the same price in the 1950s when I started driving); the whole bill coming to 11/6d (57.1/2p). J. C. Annear & Company's lorry, builders merchants made their own conversion of this 5 ton tipper by building up the body to about 7 cu. yards. This enabled the truck to carry a 5 ton load of bulk coal. It was a Morris Commercial, split windscreen with an old Cornish registration number in 1956.

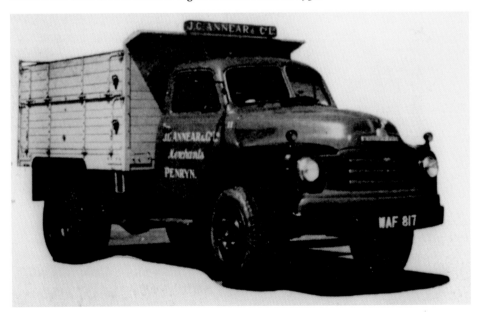

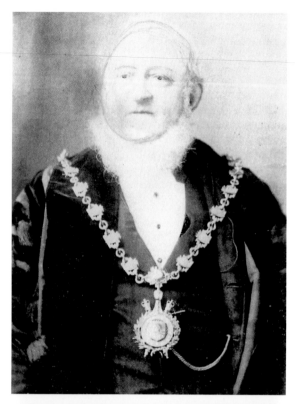

Penryn Mayors

John Bisson, from a photograph by Harrison of Falmouth; a ship owner and potato merchant, he lived in Broad Street and was Mayor during 1887, Queen Victoria's Jubilee year. From a subscription amounting to £134, the Mayoral chain was purchased. The following people subscribed as much as £25 from G. I. Bassett of Tehidy, to 5/- from Chas Phillips of Budock, John Bisson 5 guineas, T. B. Hart of Treluswell £3, Thomas Gill £2, Dr Blamey 1 guinea, West of England Granite Company, Stephens & Son, Ashfield and others gave 10/-. There were fifty subscribers in total. The chain, made of solid gold, was presented by John Bisson Esq., and other previous Mayors in attendance on 25 October 1888. It consists of a series of crowned shields and an ornamental link, from which hangs a circular medallion bearing the town's seal, and on the reverse are the arms of John Bisson. In February 1925, C. W. Andrew stated he used his Mayor's salary to have made of English oak a Mayoral chair with Moroccan leather for the seat and back. Here we see a smiling Mary May sitting in that chair. Above her head and below the carved Saracen Head is a plaque reading 'Presented by Alderman C. W. Andrew Mayor 1907-1909, 1922-1924.' Coming from Falmouth I served on Penryn Town Council in 1984; after being Deputy Mayor in 1997, I was proud to become the Mayor for the first time in 1999-2001. Financial irregularities made it very difficult as leader of the Council but I held my head high and carried on. With a second chance to wear the Mayoral chain, like 165 others before me, I was 'recycled' again in 2007 until 2011.

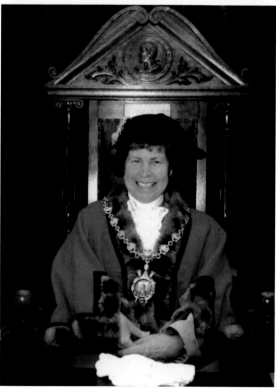

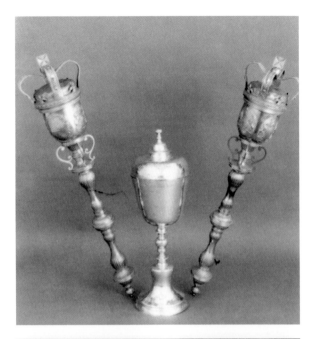

Sir Francis Bassett

The pair of Maces, presented to
Penryn in 1796 by Sir Francis
Bassett, afterwards Baron de
Dunstanville, are of silver gilt, 2 ft
10 in long, the shafts are divided
by protecting bands and have scroll
brackets supporting the heads,
enriched with the royal arms within
a garter with crests and supporters,
the arms of the donor and those of
the Borough. The Loving Cup, given
by Lady Jane Killigrew for sheltering
her when she was in trouble in 1663,
was valued then at £12 but is now
priceless. Charles Welsey Andrew,
'Father of the Council' and Mayor for
seven times, described as 'a grand
old man' of the ancient borough,
spent thirty years on the Council.
Against considerable opposition
to obtain Trelawney Gardens, he
opened them in May 1926. He was
also a JP supporting everything to
do with Penryn. It was necessary in
his younger days to earn a living as
he was not born with a silver spoon
in his mouth and not in the best of
health; he died aged eighty years.

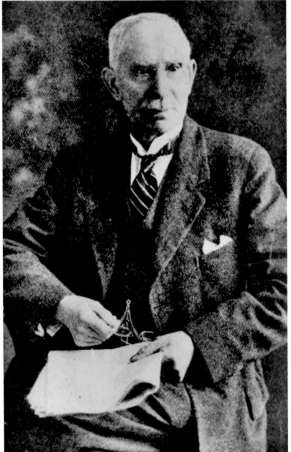

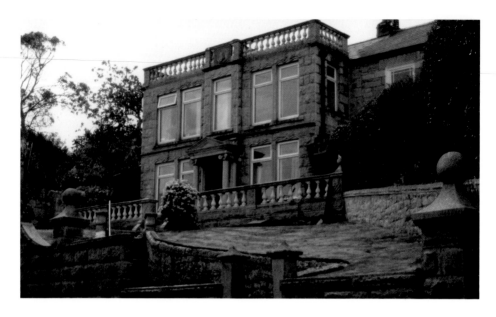

Victoria Villa

A gentleman's residence describes this modern photograph of one of the more opulent houses in Penryn, which is Victoria Villa in Kernick Road. Set off the road in an Italianate front garden was where C. W. Andrew lived. The building has a dressed granite frontage with an attractive balustrade, enjoying wonderful views of the Penryn river. It has a roof garden and an apple orchard at the back of the house. In the middle of the balustrade above the central window is a carved granite stone of a Saracens Head, Penryn's Emblem. Freeman's were not the only granite merchants in Penryn; C. W. Andrew also had a works at the top of the town near to where he lived in Green Lane. He also dealt in marble as this photograph shows him (extreme right) with his workforce of twenty men and the dog Rover. In 1930, four years after he opened Trelawney Park, he presented the Council with a sundial on a moulded granite base with a brass top, duly inscribed (see page 52). We keep hearing it is going to be returned by workmen who damaged it, but when?

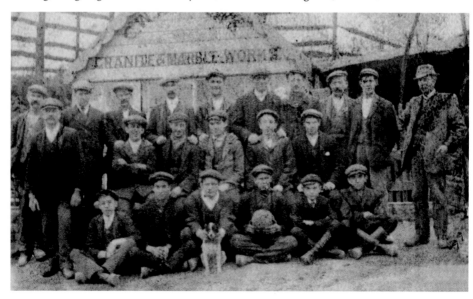

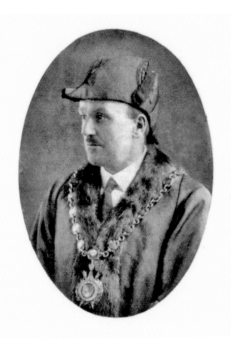

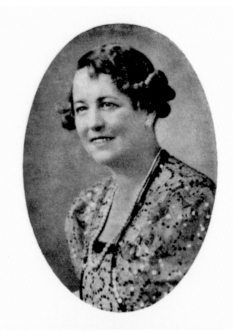

Local Heroes

Alderman and Mrs J. C. Annear Mayor of Penryn 1928-1932, 1936-1937. Businessman and ship owner, July 1930 saw the Freedom of the Borough bestowed upon C. W. Andrew; it was met with a rousing reception which deeply moved him. It was the first one to have been given to anyone. In his lengthy reply he said he was very honoured. After he had signed the scroll it was placed in a silver casket and the Mayor presented it to him. It is still in the possession of the family. Mrs Lorna Mary Smuda: 'As a 17-year-old worked for Reginald Rogers Solicitors when there were two courts held in the Town Hall, Penryn Borough and East Kerrier. I became a Penryn Town Councillor, served on Carrick and County Councils, being elected Mayor in 1987-1989 was one of my proudest moments. With tremendous support from older councillors and my husband Arnold, I decided to remain on the town council after my husband died in 1988 and am still a School Governor and Mayor's Warden for St Gluvias Church.' Here we see Mrs Lorna Smuda as Mayor with her husband Arnold (a garage owner) as Mayor Consort.

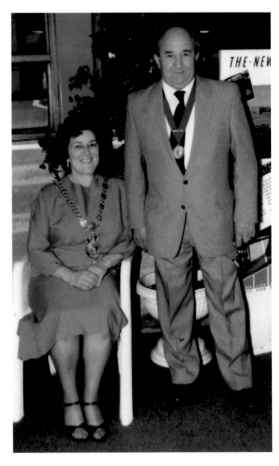

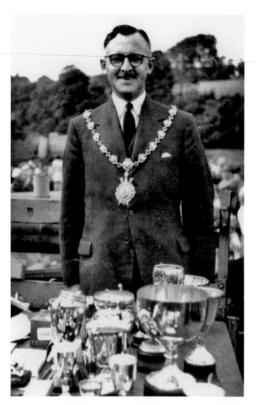

Penryn Rowing Club

Penryn's Mayor J. R. Edwards stands proudly wearing his chain of office at a prize giving believed to be Penryn Rowing Club Regatta, during his time of office 1955-1957. John Russell and his wife took over a sub post office, at 94 Market Street, from Mr Renfree. While in office both he and his wife were invited to a garden party at Buckingham Palace. He retired from business in 1968. In the interior of Penryn Town Hall, John Bisson's portrait hangs on the far wall, the door on the left is the entrance up a few granite steps from street level (brought up to date with a stair lift), and on the right is the kitchen door. The oil painting on the right is Miss Rowe, Penryn's first post mistress. It was here that the local Magistrates held Court where many a prisoner had been led down to the cells and Police Station two floors below. Immediately below the Town Hall is the Market Hall; with a beautiful slate floor used for years, it was always open late, sometimes till midnight at Christmas time. Now it is the town's museum.

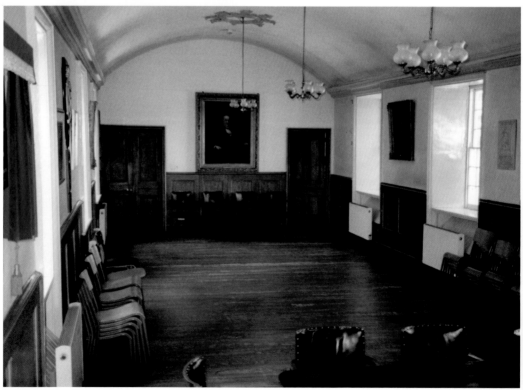

Penryn Mayors

A list of Mayors from 1900-1999. Ten years out of date, it shows some good and some not so good, but all with Penryn at heart. This photograph is of six prominent Penryn gentlemen holding what I believe to be their scrolls of the Freedom of the Borough, presented to them by J. R. Edwards, proudly wearing his chain of office as Mayor. They are, from the left: Mark Tallack, Victor Roberts, George Kingdom, L. F. Campbell, J. R. Edwards, H. B. Jennings, P. T. Dancer. All are ex-Mayors with scrolls, except L. F. Campbell (town clerk) and Victor Roberts, who was awarded for his rugby career, Captain of the Lions, England, Cornwall and Penryn etc.

MAYORS OF THIS TOWN
OVER THE CENTURY

	
1900-1902	Benjamin Williams Curgenven
1902-1904	Richard Ambrose Newcombe
1904-1907	James Powell
1907-1910	Charles Wesley Andrew
1910-1912	Alfred Geach
1912-1914	George Read
1914-1919	Benjamin Annear
1919-1922	John Marshall Thomas
1922-1926	Charles Wesley Andrew
1926-1928	Fred Richards
1928-1932	Joseph Charles Annear
1932-1936	Alfred Teague Greenwood
1936-1937	Joseph Charles Annear
1937-1940	George James Pellowe
1940-1944	William Charles Basher
1944 Nov 1949	Henry Benjamin Jennings
1949-1943	Frank Harris
1943-1945	Philip Trevarno Dancer
1945-1947	John Russell Edwards
1947-1949	Edwin Leslie Jenkin
1949-1961	Stanley Thomas
1961-1963	Frederick Mark Tallack
1963-1965	William George Bewetherick
1965-1968	Edwin Charles Gwyther
1968-1970	Mrs Doris May Williams
1970-	Douglas Herbert Lewis Thomas
1970-1973	Mrs Emma Vernie Crevatte-Ball
1973-1975	Arthur Clarence Dunstan
1975-1976	Roger David Hunt
1976-1978	Joshua Charles Bedford Daniels
1978-1980	Rev Donald John Forway
1980-1982	John Stanley Astwin
1982-1984	Jack Chinn
1984-1985	Peter John Pollard
1985-1987	David Lloyd George Hocking
1987-1989	Mrs Lorna Mary Smuda
1989-1991	Alan Curtess
1991-1993	Leonard Dudley Brokenshire
1993-1995	Mrs Penelope Lucinda Vinnicombe
1995-1997	Harry David Grant
1997-1999	Leonard Dudley Brokenshire
1999-	Mrs Mary May

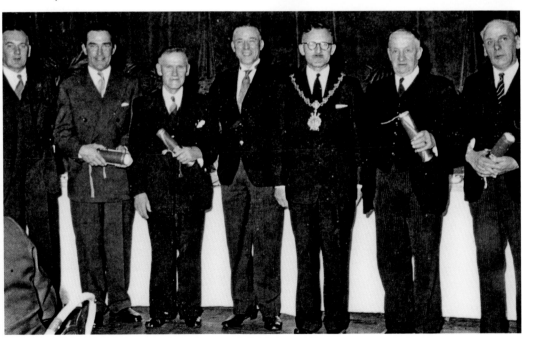

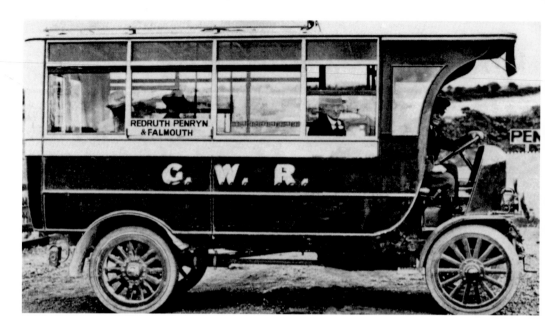

Penryn Buses

A GWR bus stopping at Penryn station, the designation board states it came from Redruth and finishes at Falmouth. I am unable to distinguish the registration number, but it is a Burford, running on solid tyres, has oil lamps, and with a starting handle it would be from around 1910-12; another runs in the Helston area. Moving on about 100 years, this First Bus is passing the Methodist Church on the left with the Nunnery seen on the top right. Workmen are replacing granite blocks that once held a bollard that motorists kept knocking down on the left in the fenced off area.

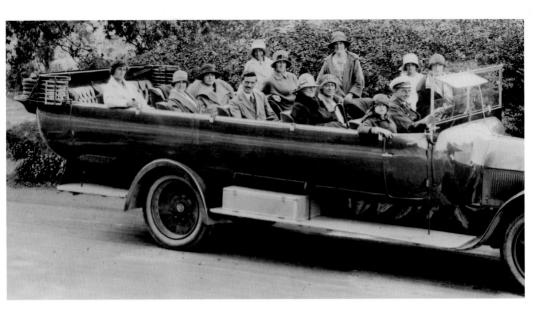

Days Out

In around 1920 this group of Penryn people took a trip on one of Rickards buses, driven by Jack Rapson. It must have been a cold dry day, with the hood down and passengers wearing coats and hats, while the driver's side of the spilt windscreen is open. I think it is a Napier with 30hp. Seating approximately twenty people, running on pneumatic tyres, the skirt between the body and running boards have seen better days, making me think it was new in around 1914. MRL 863, HD 7893 are Pelere Motors both going to Penryn, the larger to Greenwood Crescent, the body of which was formally fitted to a Southern National Bus, standing outside the Falmouth Town Hall on the Moor. Pelere Motors started in 1927 with a Chevrolet going between Falmouth and Stithians but did not observe a regular timetable until after 1931. There was a service named 'Dinner Basket Bus', where workmen's wives would prepare a hot meal, and pay the driver two pence to take the baskets of food to Falmouth Docks for the hungry men. After forty years' service, the company was sold to Grenville Motors in 1967.

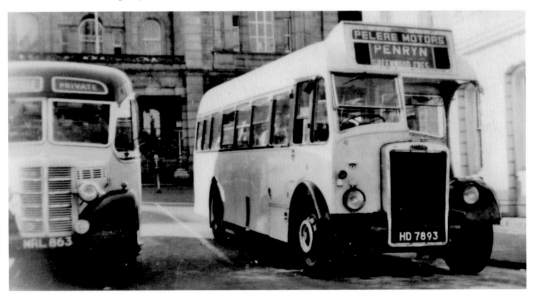

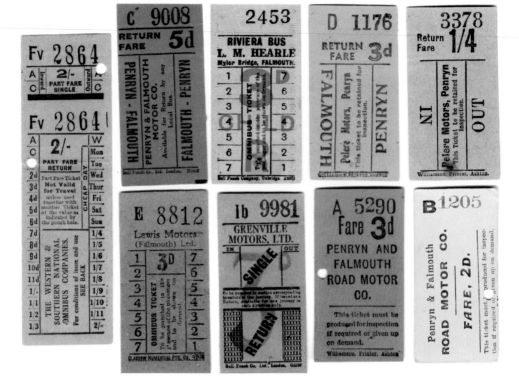

Bus Tickets

Market Street, with a double-decker First Bus stopped to take on or drop off passengers on its way to Falmouth. Note the number of cars parked on each side of the street; Penryn really has a parking problem. These old bus tickets from *c.* 1915 to 1950s used by a variety of vehicles that passed through the town.

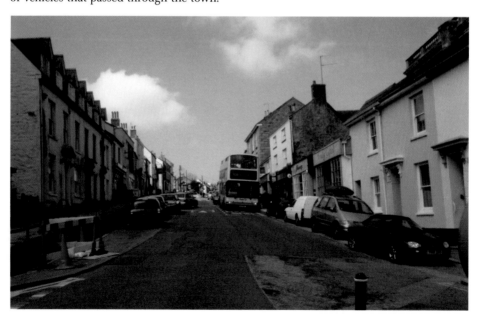

Penryn Buses

Albert Edward Lewis has been involved in the motor trade since 1914 as a partner with S. L. Taylor of Taylor's Garage. In 1929, the partnership was dissolved; with his two sisters they formed Lewis Motors. Named 'Silver Tours' they ran excursions to Newquay or Perranporth for 6/-. From the left, LRL 565 is an AEC Regal III 1949, LCV 194 is a TSM of 1949, as is KCV 578, KTF 6 is another AEC Regal III, with their drivers and manager or owner Mr Taylor. GRL 648 passing the Falmouth Library, about to park outside the Town Hall; this Rickards bus is a Bedford OWB with 33 seats of 1952 vintage. In March 1912, a 27hp Lacre motor vehicle, registration AF798, fitted with solid tyres and a 'toast rack' charabanc body was purchased, it could carry 28 passengers; in June of the same year, another Lacre AF848 arrived, and so began a new service between the two towns of Penryn and Falmouth. They were kept at premises at The Praze.

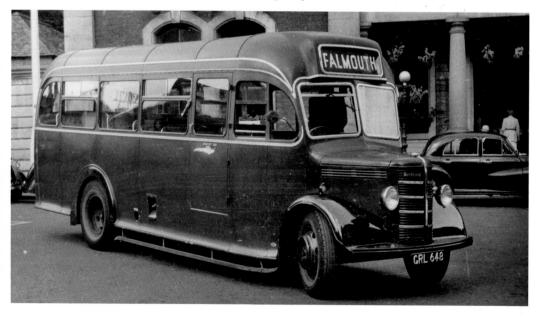

Samuel Gurney and Sir Julius Vogel
Samuel Gurney, born in 1816, was the
second son of the bankers Samuel Gurney
and a partner in Overland Gurney. He
became a Member of Parliament for Penryn
and Falmouth in 1857-1865. He was also
the Sherriff of Surrey while still an MP
and was a director of several telegraph
companies. Sir Julius Vogel, born in 1835,
was of a Jewish family and never wanted
for anything; with gold being discovered in
Australia he arrived in Melbourne in 1852
and established an assaying and importing
business. By 1861, Victoria was in recession,
so he moved to Dunedin, the newest gold
town in New Zealand. For almost twenty
years he was in and out of the New Zealand
Parliament. Returning to England he
secured the Conservative Party nomination
for the Borough of Penryn and Falmouth,
1880. The Conservatives were soundly
beaten so he was not elected. His health
deteriorated and he had money problems;
he died aged sixty-four years in 1899.

Parliamentary Election, 1910.

To the Electors of Penryn, Falmouth, and Flushing.

WHAT more pathetic and touching picture can arrest and engage the attention than the one on the other side of this card. It pourtrays more eloquently than words the **disastrous effects** which **"Free Trade"** has produced in the Homes of British Working Men. What is true of your Granite industry is equally true of almost every other industry in this Country. If, then, we want our decaying trades revived, our sons of toil to be more regularly employed, their wages increased, and our homes made more comfortable and happy, then it behoves us to give Tariff Reform a trial, seeing that the present state of the Country is the result of following Free Trade for sixty years.

VOTE FOR GOLDMAN,

who lives amongst you,

AND TARIFF REFORM,

which means British Work for British Hands.

Printed and Published by J. H. Lake & Co., 11 and 12, Market Strand, Falmouth.

PRINTED & PUBLISHED BY DAVID ALLEN & SONS, LTD., 180, FLEET ST., E.C.

Local MPs

Vote for Charles Goldman. He served the constituency from 1910-1918 and lived with his wife Mary at Trefusis House. Born in 1868 in Cape Colony, he was adopted by a family called Monck. He spent most of his life in the Transvaal making a fortune from gold and diamonds. He settled in Falmouth and became an MP, entrepreneur, author, and Director of Falmouth Golf Club. His youngest son was named Penryn Monck. During the First World War he was a Major in the Cornwall Royal Garrison Artillery; he died in 1958 aged ninety years. With boundary changes, Penryn is no longer connected with Camborne. At the last general election in May it came in with Truro and St Austell after Matthew Taylor retired for family reasons. The newly elected MP is a honey blonde Conservative Mrs Sarah Newton, who from the age of six months was brought up in Falmouth, is married to a Solicitor with three children and lives at Mylor Bridge. I hope she gets on well and look forward to reading her column in the *West Briton* every week.

Walter J. Birt

At the general election in 1910, Charles Goldman entered Parliament as a Conservative led by Arthur Belfour. The election produced a hung Parliament. Liberals led by H. H. Asquith had two more MPs. A second election was held in December. This postcard by Bragg, a Falmouth photographer, shows Walter J. Burt (who must have been a local man) as a Liberal candidate for the united Borough of Falmouth, Penryn and Flushing, December 1910. He was not successful as Goldman was returned. This time the Liberal party formed a Government with the support of the Irish Nationalist (so what's new).

It is *Whispered, that*

Mr. Sowell

Of PENRYN,

Is just arrived at

FOWEY,

TO MEET THE

CANDIDATES

About to *canvass* the Borough in the Interests of

JAMES HILL, ESQ.
LIEUT. NICHOLLS!!

DATED 28th September, 1824. [LANE, PRINTER, FOWEY.]

Dated 1824, this poster may have helped?

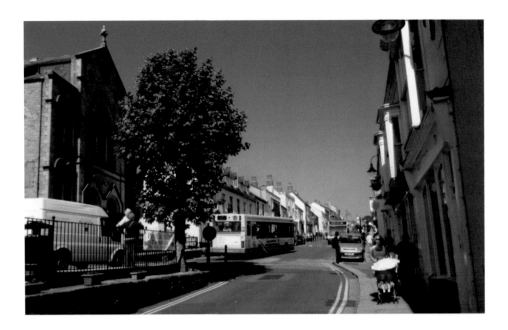

Main Street Penryn

Main Street in Penryn, taken from opposite the Methodist Church; the tree in full leaf was planted in 1902 to commemorate the Coronation of King Edward VII. With yellow lines and two buses about to pass each other, it looks busy on a Friday morning. I am wondering if this is just heavy traffic, or is it Carnival time in Penryn? There are a lot of people lining the streets. What a lovely small open-top private bus with a large rear window; this 14-seater bus could have belonged to 'Ginger Harry' who lived nearby. Austin, Morris, and Ford cars are prominent in the procession, with the flags out when this was snapped outside or near the Seven Stars in the late 1920s or early 1930s.

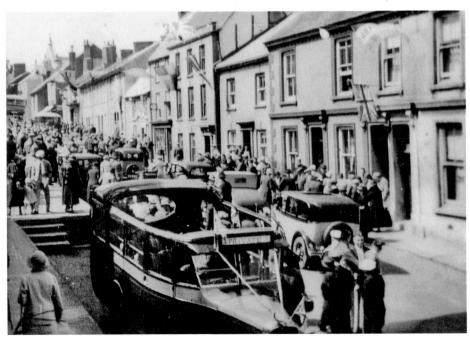

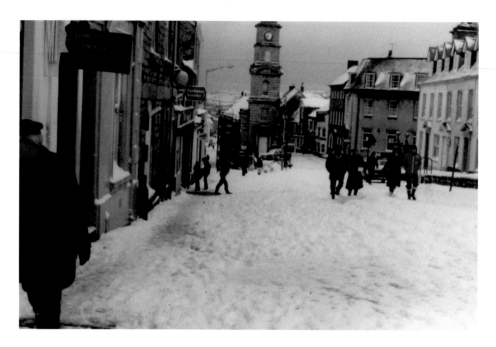

Market Street

The year 1963 saw a heavy fall of snow, with no traffic moving but a few people making their way up Market Street. With the Wesleyan Chapel on the right, outside of which are the white glass globes at the entrance to this place of worship, and one of many trees, planted to commemorate Edward VII's Coronation in 1902, in full bloom, with the door of the Town Hall behind it, and a black faced clock, this photograph can be dated from around 1905. The buildings next to the globes were demolished to build a road into a council housing estate about to be built named Saracen. All looks peaceful, even with the horse and carriage waiting to be hired.

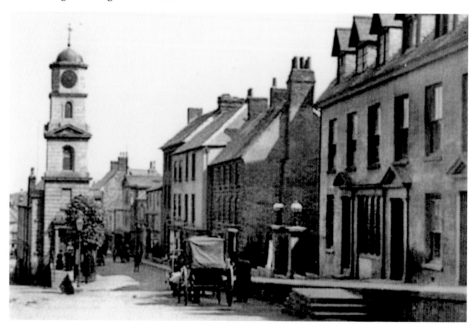

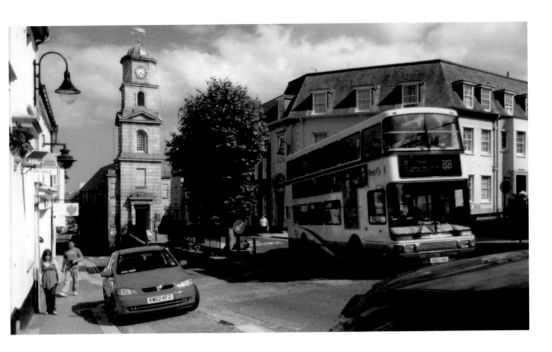

Town Clock

The town clock shows it is twenty-five to five on a lovely day; a number 88 double-decker bus is on its way from Falmouth, destined for Truro some eight miles away. How times have changed; below the street light on the left is a CCTV camera, with a house for sale next to Barclays Bank. Having moved on 100 years or so, the tree is still there, only the trunk is larger. An hour out from the last picture and moving to 1969, with a Mini car, Austin A35 van and a Ford behind the railing, these ladies must think it to be safe to walk in the middle of the road, even with yellow lines unlike the last one. James Stores on the left sold household furnishings etc. and even produced a free weekly newspaper for a short while.

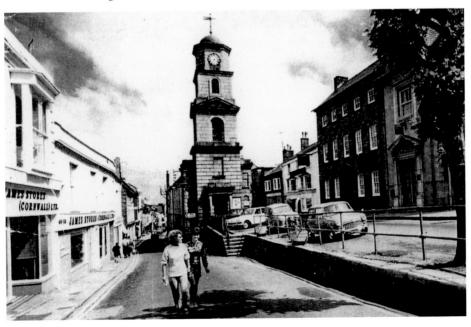

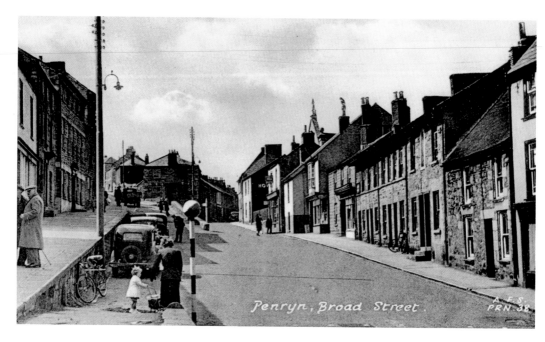

Higher Market Street

Believe me, this is not Broad Street – I know, I lived with my family on The Terrace (the nearest canopy) – it is Higher Market Street. Compare the two pictures – how they have changed. Both were taken from outside the Seven Stars public house. The belisha crossing has been moved to where the photograph was taken, while a bus shelter and railings have been added. The houses are the same, and cars more modernised. The postcard shows Helston Road on the left and West Street to the right; the only transport on the right is a bicycle. Where a couple of people are standing in the middle background was Belbin's bread shop that sold all sorts of confectionery including Hovis, then there was Rundles shop, a grocer, then J. R. Edwards post office and stores. The bread shop is now a glass blowers; the other two are closed.

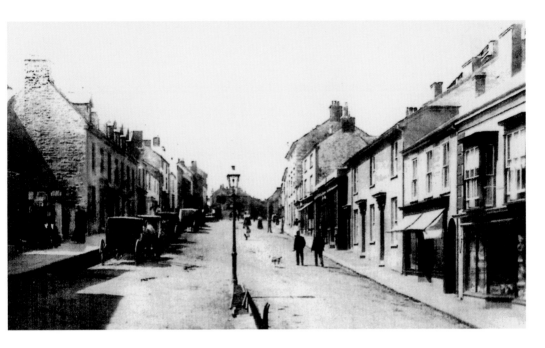

Changing Views

Going back perhaps 110 years with a single gas lamp dividing the main street, with carriages on the left waiting to be hired outside the Wesleyan Chapel, the entrance globes have yet to be illuminated, with two men and a dog it all looks peaceful. The shops on the right I remember as Eddy Moon (ladies wear) and Thomas Dunstan (ironmonger). Moving on today from the same position, motorised transport replaces the horse and cart, people still stand and talk, one tree still stands, now over 100 years old, and Eddy Moons is now Barclays Bank with a CCTV camera above. Railings are in position to stop people from falling into the lower street.

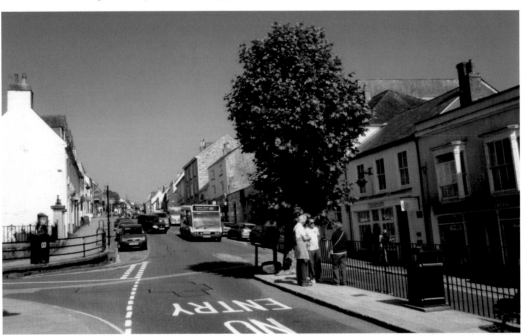

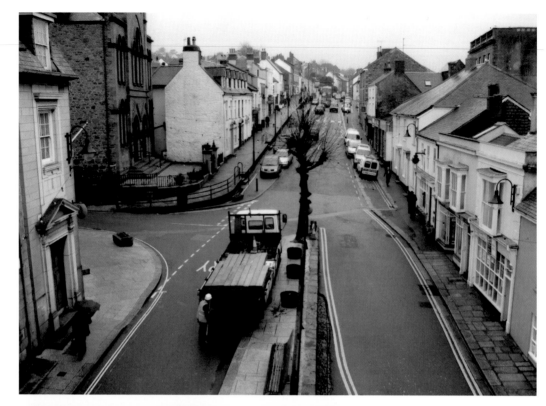

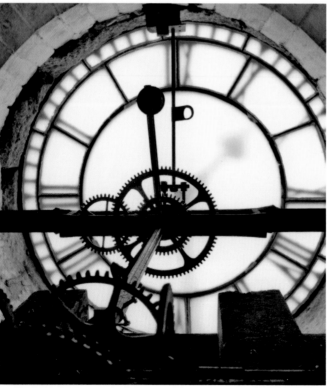

Clock Tower

The road on the left to the council houses is clearly seen from this photograph taken from the clock tower. After all the previous postcards and photographs, see the difference to the main street, from carriages to modern transport with yellow lines to stop parking. The lorry is unloading scaffolding for repairs to the clock tower. Where the lady with the umbrella is walking are the Council offices. The only thing the same in all the pictures are the rooftops!!! This lovely photograph was taken inside the clock tower showing the huge clock mechanism. The question is what time was it when the photograph was taken? Are you sure?

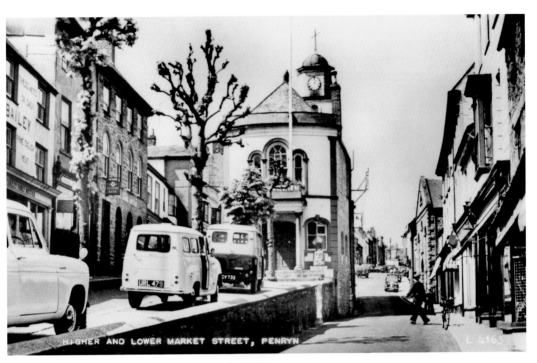

HIGHER AND LOWER MARKET STREET, PENRYN

Fish Cross

Taken from the other side of the town clock, cars and vans are parked between the trees; to the left is Tom Bailey's butcher's shop, almost next door to Lloyds Bank. The rounded top windows are of the Council Chamber, next to one of the pillars supporting a balcony is a small granite monument that came from Fish Cross a number of years ago, and to the right again the building with the pointed roof is the Temperance Hall, at one time a cinema. Fish Cross was where this photograph was taken; it is a fore cross road. Main Street and New Street are to the right where the yellow lines curve, with Broad Street behind and St Thomas Street to the left. It was here that ladies sold fish and oysters many years ago.

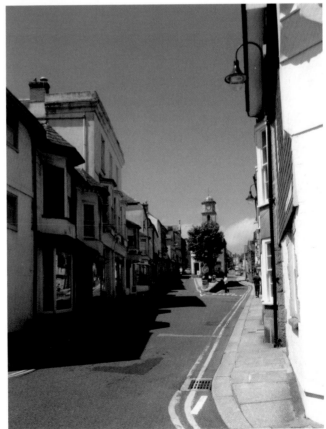

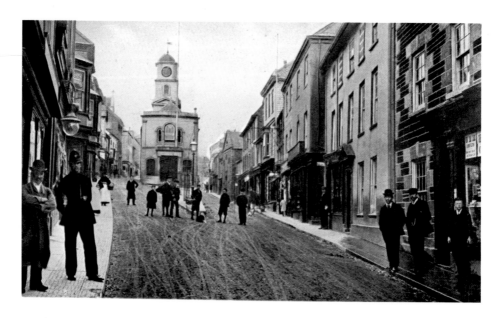

Market Street

A common postcard clearly shows the town clock, Town Hall and Market Hall. The policeman is believed to be called Bullock, the gentleman with the bowler hat could be Mr Thomas standing outside his watch and clock shop, and on the other side of the street where the men are standing is the newsagent of Chegwidden, next up from there is Henry Trudgeon, a high class baker, confectioner, restaurant and shop. It was dated and posted from Penryn in 1906. With the King's Arms on the right it has a granite-pillared viewing room; from this room it is possible to look up the street towards the clock, behind is Broad Street and opposite is St Thomas Street, where on the corner for many years Mrs Jewell had a grocery shop selling a wide range of chocolate and cocoa, and next door is a fish and chip shop. Behind the trees on the left there was once housed a horse-drawn fire engine. Freemasons held their meetings at the King's Arms at different times in 1782 for a short while and again in 1863. The King's Arms was once known as Chapman's Hotel when George Chapman was the owner in 1872.

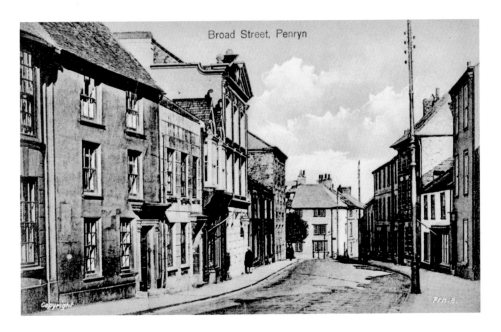

Broad Street, Penryn

Broad Street

As it says this is Broad Street; these impressive houses once belonged to ship owners, council officials, shop owners, etc. On the left a new post office was built in 1905 where a sign hangs on the outside wall saying public telephone. On the same side of the street some of the houses behind the tree were destroyed in a bombing raid in May 1941 where eighteen people were killed and twenty-three houses, one shop and church institute in the Mill Lane, Quay Hill area were demolished. This is the old fire station built in 1899 at the top of St Thomas Street or at Fish Cross. The engine was pulled by two horses stabled at The Glebe. Imagine it pouring down with rain, having to fetch the horses and couple them up to the engine, then fill the machine with water and have to go a mile away to a fire that is burning; the rain would have helped more than the firemen.

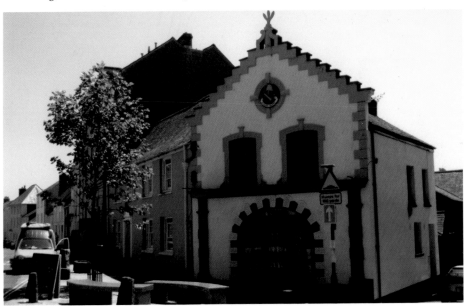

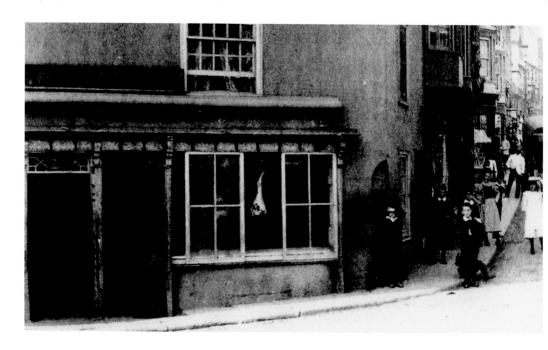

St Thomas Street

This is to the right of the old fire station at the top of St Thomas Street on the corner, where this photograph was taken in 1897. The butcher's shop of Robert Tresidder is open for business with a single leg of meat hanging in the open window and around the corner in the Main Street everyone had stopped to watch the photographer. The outside lamps of Malletts shop are visible. This up-to-date photograph was taken from the Memorial Garden dedicated to the people who died during the air raid on Penryn in 1941. The houses on The Green were destroyed, making way for the bowling green to be laid; the helicopter was doing a display in the harbour.

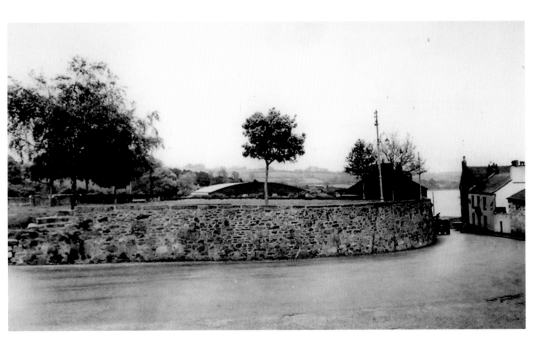

The Green

Taken just after the war, this is what The Green and Quay Hill looked like before it was redeveloped. The Green was used for most events then, and Anderton and Rowlands fair visited several times a year. The rounded top of Annear's coal yard is visible as is the Anchor Hotel public house. Moving on fifty years, Quay Hill as it was not so long ago, all the buildings have been demolished and boarded up with vegetation growing profusely, a few small coasters are in the harbour, with yellow lines painted on the road and cars parked everywhere.

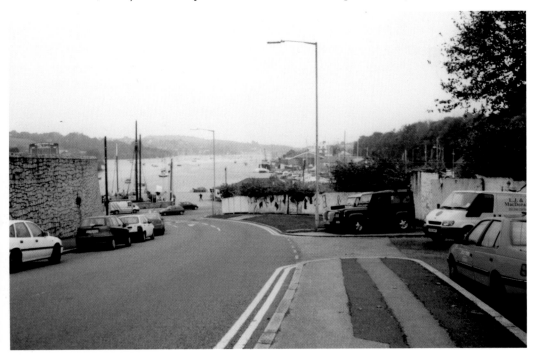

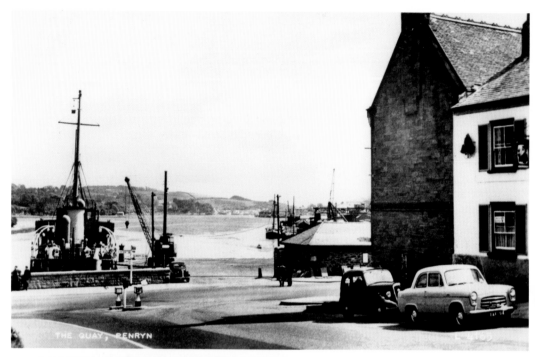

Quay Hill

When this postcard was taken in 1961, it shows Quay Hill with motor cars parked outside the Anchor Hotel public house, no traffic lights yet but there are bollards with men chatting away leaning on the wall and a small coaster being unloaded behind them. Freeman's yard is seen on the extreme right, still working. Taken at five minutes past midnight standing in front of the town clock, is my wife and myself at Penryn's 2000 celebrations. I hope you have enjoyed reading my book, it was completely different and a challenge. I am always looking for postcards and photographs with ANYTHING to do with the Borough of Penryn, just to copy; they will be returned without fail. Will the person who gave me a copy of the Datson Boot Factory please, please contact me again. A lot of my pictures have been altered to stop copying.